This book was published with the
generous support of the following
individuals and organizations:
James and Charlene Harvey Foundation
Pentagram Design Inc.
Potlatch Corporation
Graphic Arts Center/Portland, Oregon

Library of Congress Cataloging-in-Publication
Data available. ISBN 0-8118-0874-2

10 9 8 7 6 5 4 3 2 1

Golden Gate National Park Association
Fort Mason, Building 201
San Francisco, CA 94123

Chronicle Books
275 Fifth Street
San Francisco, CA 94103

PRESIDIO GATEWAYS

VIEWS OF A NATIONAL LANDMARK AT SAN FRANCISCO'S GOLDEN GATE

PHOTOGRAPHY BY

ROBERT GLENN KETCHUM,
LINDA BUTLER, AND MARY SWISHER

WITH CONTRIBUTIONS BY

LYLE GOMES AND BRENDA THARP

TEXT BY

DELPHINE HIRASUNA

WITH AN AFTERWORD BY

ROGER G. KENNEDY
DIRECTOR, NATIONAL PARK SERVICE

GOLDEN GATE
NATIONAL PARK ASSOCIATION

CHRONICLE BOOKS • SAN FRANCISCO

Presidio Gateways

Although there are literal gateways to be found on Presidio grounds, the gateways here are metaphorical, serving to focus the reader's attention on the major aspects of the area and to provide a structure within which to discuss its qualities. Through these "gateways," the reader enters the grounds of the living past and sees the vision of what the Presidio is and what it can become.

Guardian of the Golden Gate

Sentry to a great natural harbor, the Presidio was established as a Spanish colonial outpost in 1776. Since then, it has flown the flags of three nations.

1

Presidio Map

A visitor's guide to the Presidio, this colorful map points out important military architecture, historic landmarks, and scenic attractions that can be found in this 1,480-acre national park.

20

North Gate

The symbolic entrance not only to the Presidio but to the American West, the Golden Gate gave purpose to Fort Point and Fort Winfield Scott, which represent two distinct eras in the Presidio's history.

24

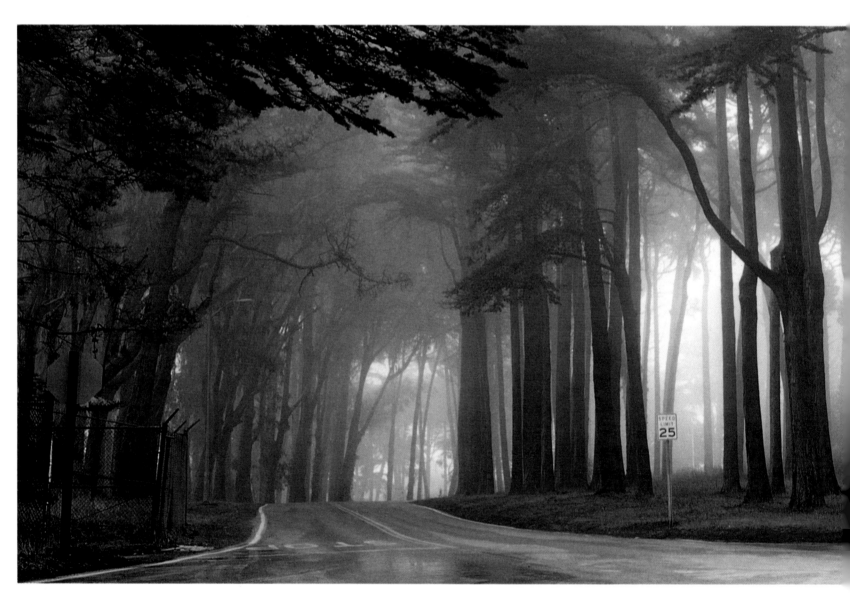

SOUTH GATE

An urban oasis long shared with its nearby civilian neighbors, the southern portion of the Presidio features forested slopes, hiking trails, parks, a golf course, and stately old military homes.

56

EAST GATE

Featuring one of the finest outdoor museums of U.S. military architecture in the nation, the Main Post, near the east entrance, has been the heart of the Presidio since 1776.

74

WEST GATE

The wildest part of the Presidio, the coastal bluffs that look out over the Pacific Ocean still harbor a number of native plant communities as well as defense batteries dating to the 1890s.

98

GATEWAY TO THE FUTURE

Roger Kennedy, director of the National Park Service, discusses the significance of creating an urban national park and environmental study center at this historic military post.

117

THE CREATIVE TEAM

The biographies of the creative team that produced this book are presented here, along with comments from the five photographers, Robert Glenn Ketchum, Linda Butler, Mary Swisher, Lyle Gomes, and Brenda Tharp.

126

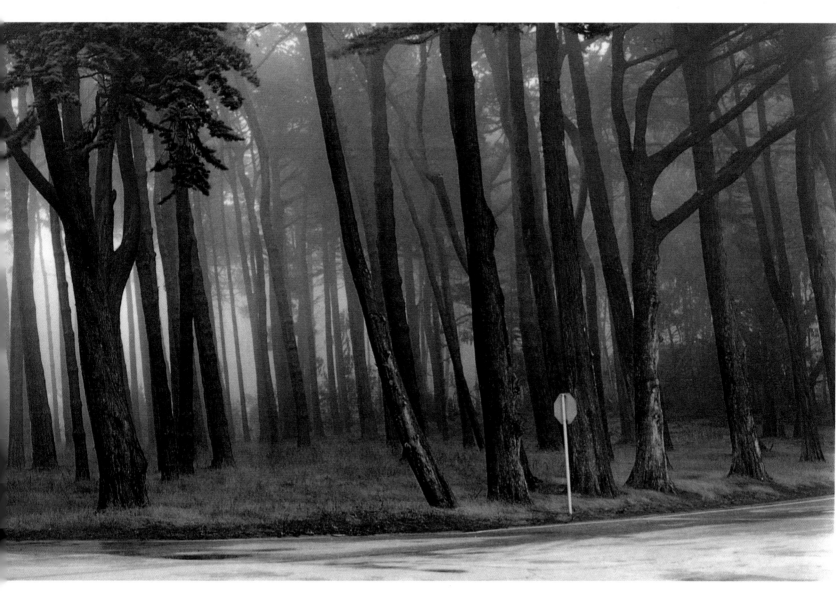

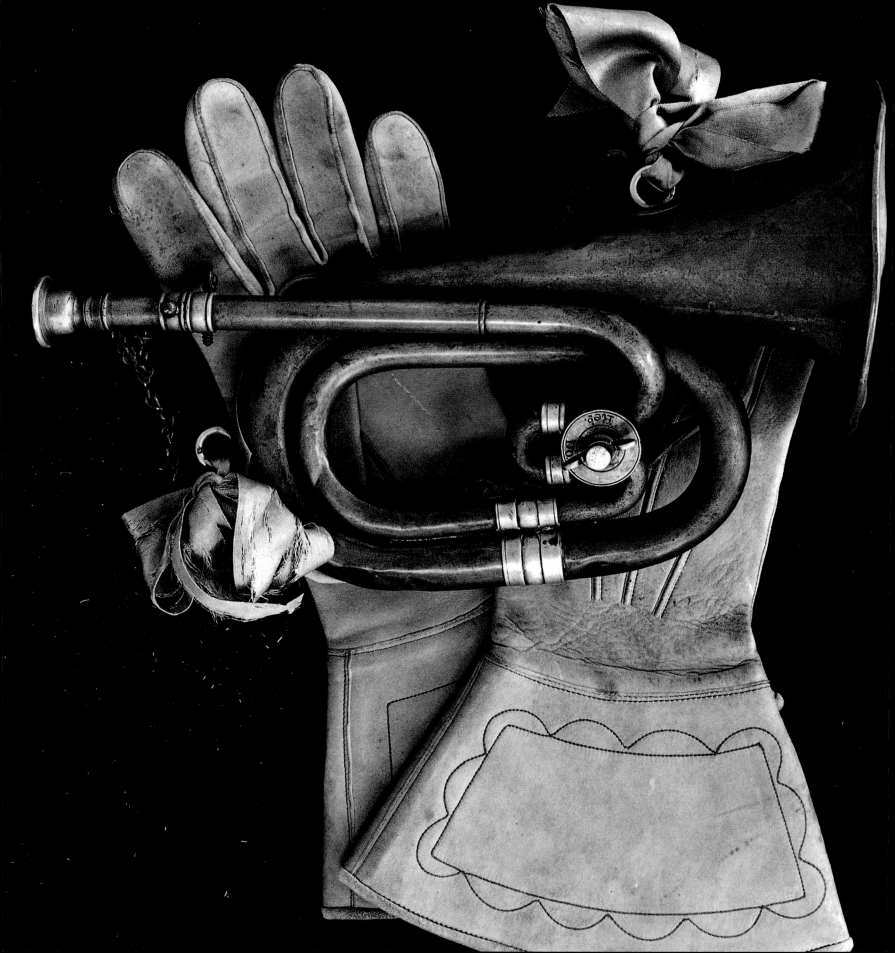

GUARDIAN OF THE GOLDEN GATE

A LOOK THROUGH TIME

From the Presidio headlands overlooking the Golden Gate, one can clearly see why this strait into one of the world's most magnificent natural harbors played a pivotal role in the history of the American West. "If California ever becomes a prosperous country, this bay will be the center of its prosperity," predicted writer Richard Henry Dana during his two years before the mast. For thousands of years, the rich land and sea supported the Ohlone, Miwok, and other indigenous peoples. The Bay Area's largess proved to be an irresistible magnet over the centuries: Spanish explorers, Russian whalers, English adventurers, hopeful gold seekers, and Asian immigrants were drawn to its shores. The nation's oldest continuously operated military post, the Presidio of San Francisco has successively flown

the flags of three countries—Spain, Mexico, and the United States. The Spanish, the first Europeans to claim this territory, were quick to establish the Presidio to stand sentry over this coveted bay. Initially the northernmost military outpost of the Spanish colonial empire, the Presidio was founded on September 17, 1776, shortly after Captain Juan Bautista de Anza III took formal possession of the land around San Francisco Bay for the King of Spain. The post was the first settlement in San Francisco, predating Mission Dolores. It was a humble beginning. British Navy captain George Vancouver

Entrance from Presidio Boulevard, ca. 1906.

described what he saw when he visited the base in 1792. "Instead of a city or town, whose lights we had so anxiously looked for on the night of our arrival, we were conducted into a

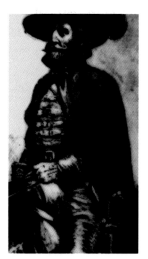

Instructed by the Spanish viceroy to provide "in that port [San Francisco] a certain sign of defense to indicate that it belongs to his Majesty," Captain Juan Bautista de Anza III established a colonial outpost overlooking the Golden Gate in 1776.

spacious verdant plain, surrounded by hills on every side, excepting that which fronted the port. The only object which presented itself was a square area, whose sides were about two hundred yards in length, enclosed by a mud wall and resembling a pound for cattle." **R**avaged by storms, earthquakes, and floods over the years, the adobe and stone quadrangle steadily deteriorated. With more serious problems in both

Europe and America, Spain allowed the Presidio to decline after 1810, despite occasional spurts of repairs. **T**he Mexican Revolution in 1821 gave Mexico possession of the Presidio along with all Spanish land in America. However, the new Mexican government paid little attention to its northern colonies, and by 1835, the post was in caretaker status. The few abandoned cannons overlooking the Golden Gate outnumbered the soldiers stationed there. **W**hen war erupted between Mexico and the United States in 1846, U.S. soldiers seized the Presidio along with the territory of California. U.S. Army Lieutenant John C. Fremont led a civilian force that included the legendary scout Kit Carson and twenty Delaware Indians into the Presidio and drove spikes into the touch holes of the cannons. **A**t first, the number of soldiers at the Presidio remained small, especially when the California Gold Rush of 1848 tempted men to desert. But San Francisco quickly

80 pieces O.P. 6x6x11 =	2640 ft,	for uprights	$ 52.80
510 running ft O.P. 4x8 =	1360 "	Mud sills	$ 27.20
80 pieces O.P. 4x8x8 =	1040	Supports for braces &c	$ 20.80
518 running ft O.P. 3x6 =	7..	Top plates	$ 15.54
50 pieces O.P. 4x6x12 =	.. "	Braces	$ 24.00
68 pieces O.P. 3x6x34 =	346 "	Girders	$ 69.36
140 pieces O.P. 2x6x2 =	3.80 "	Rafters	$ 61.60
3000 ft O.P. 1x..x12 =	3000 "	Side braces for Rafters	$ 60.00
10.000 ft ...wood Boards. Clear. for roofing			$ 200.00
450 pie... Battens. 22 feet long. 4 inches wide. ½ in thick			$ 12.00
32 pieces ..P. 2x4x16 = 524 ft		for gable ends	$ 10.80
14 " O.P. 2x4x16 = 238 ft		running braces	$ 4.76
5000 running ft O.P. 2in planks. = 10.000 ft.			$ 200.00
500# Us Cut nails. $\frac{10}{100}$. $\frac{12}{200}$. $\frac{30}{100}$. $\frac{..}{100}$			$ 20.00

For material $778.86

For hire of two Civilian Carpenters 18 days each @ 3½ pr day $ 126.00

Total cost. $904.86

Frank Fuller.
1st Lieut ... R.Q.M. 4 ... A.Q.M.

Sir: I have the honor to transmit herewith Estimates of material required to build a Coal Bin. On account of the short time left in which to build it I respectfully request that authority

burgeoned into the gateway to the gold fields, and by late 1849, more than five hundred vessels were anchored off its waterfront. In the early 1850s, the army constructed a new system of harbor defenses that extended beyond the boundaries of the Presidio to include fortifications at Fort Point and the island of Alcatraz. During the Civil War, these fortifications proved timely. Control of San Francisco Bay meant control of the immense wealth represented by the gold and silver resources of California and Nevada. Fortification of the Golden Gate became the Union's main hope in thwarting Confederate schemes, which came

The Presidio's field artillery mounted in formation at the Main Post in 1910.

perilously close to success. The presence of Confederate privateers in the Pacific and fear of losing this territory to the South led to construction of what are now the Presidio's oldest surviving buildings. Following the Union victory, troops from all over the nation funneled

Following the Mexican Revolution against Spain, which ended in 1821, the Mexican flag flew over the Presidio, but when war erupted between Mexico and the United States in 1846, U.S. soldiers quickly occupied the military installation, and the Mexican flag came down.

through the Presidio on their way to fight in the Indian Wars of 1865-1890. To house incoming troops, the army added to the number of cavalry and infantry barracks. Increasingly, the Presidio became the cornerstone of U.S. military operations in the West. In recognition of this role, the army designated the Presidio burial grounds a national military cemetery in the 1880s. It also undertook an ambitious

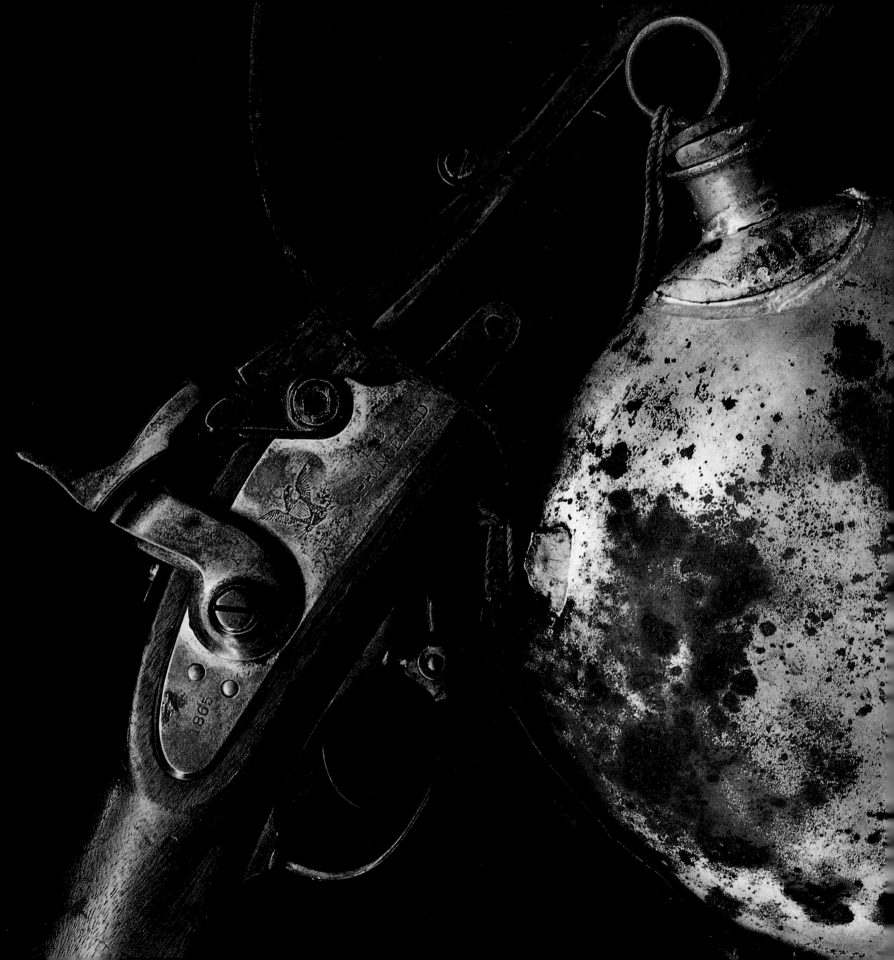

forestation program to beautify the base, resulting in the Presidio's modern appearance. Practicality as much as aesthetics dictated the planting of more than 400,000 tree seedlings on what had been mostly grassland and scrub. The trees formed effective windbreaks, anchored sand dunes, stemmed erosion, and mitigated the Presidio's well-founded reputation as a cold, windswept, and undesirable post. As the western frontier closed, the Presidio responded to a new mission of American imperial expansion overseas. Thousands of volunteers and regular troops mustered at the post prior to shipping off for the Spanish-American War and the Filipino Insurrection. During this period, the Presidio strengthened its coastal fortifications by installing a string of massive concrete gun batteries on the bluffs overlooking the Golden Gate. It also served public needs in immediate local ways. When San Francisco was rocked by the great earthquake

and fire of 1906, the Presidio, which had suffered comparatively little damage, provided refuge for an estimated sixteen thousand San Franciscans who were left homeless. In 1915, the Panama-Pacific International Exposition was held on part of the Presidio grounds to celebrate the city's rebirth after the devastation. The start of World War I forced the exposition to close early, and the base became a training ground for troops bound for France. The area now used for the golf course was a "no-man's land" of trenches and barbed wire entanglements. Air defense also came to the Presidio; Crissy Field, constructed in 1921, served the military

in the eight western states. Space limitations and hazardous weather conditions forced the airfield to be abandoned just fifteen years later, except for limited use during World War II. **W**ith the Japanese attack on

Since its establishment in 1776, the Presidio has witnessed the evolution of military uniforms. This uniform was worn by a quartermaster during the period of the Indian Wars, ca. 1865.

Pearl Harbor, the Presidio immediately became the Western Defense Command, and functioned as a staging area for American forces throughout the war. An old hangar at Crissy Field was converted into a foreign language training school for Nisei (second generation Japanese-American) soldiers who served as translators and interrogators for the field forces.

Bordered by cannonballs, the Alameda, or promenade, originally marked the formal entrance to the Presidio's main parade ground.

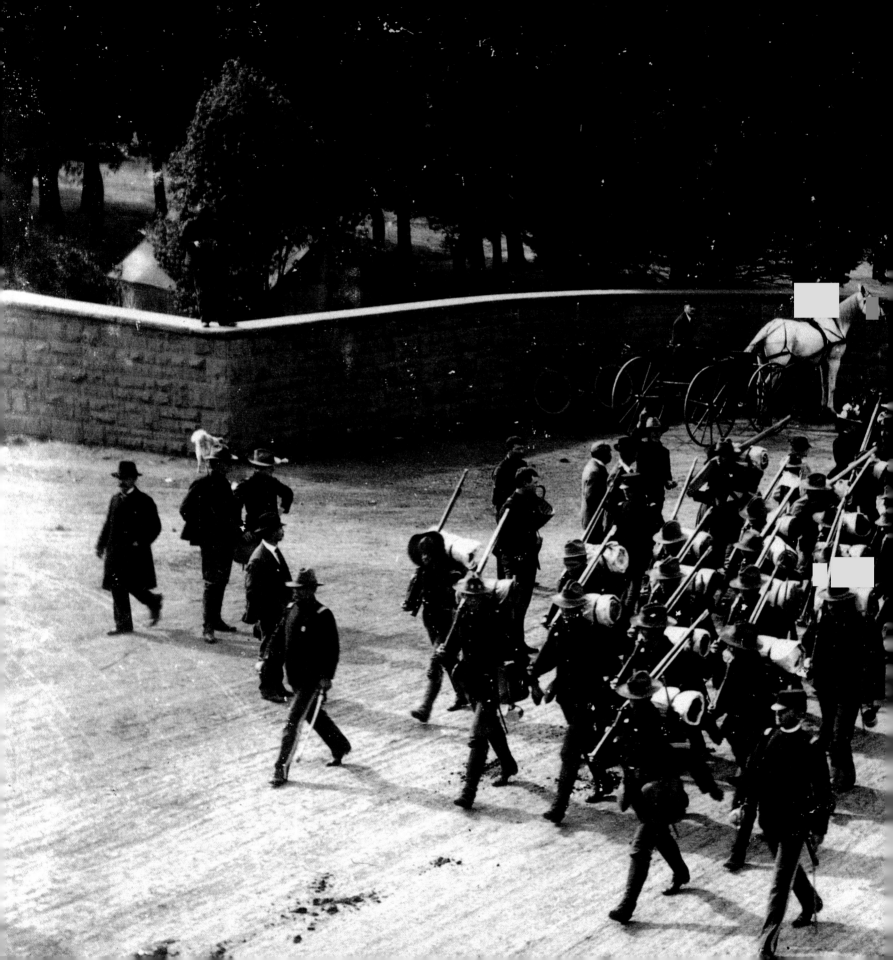

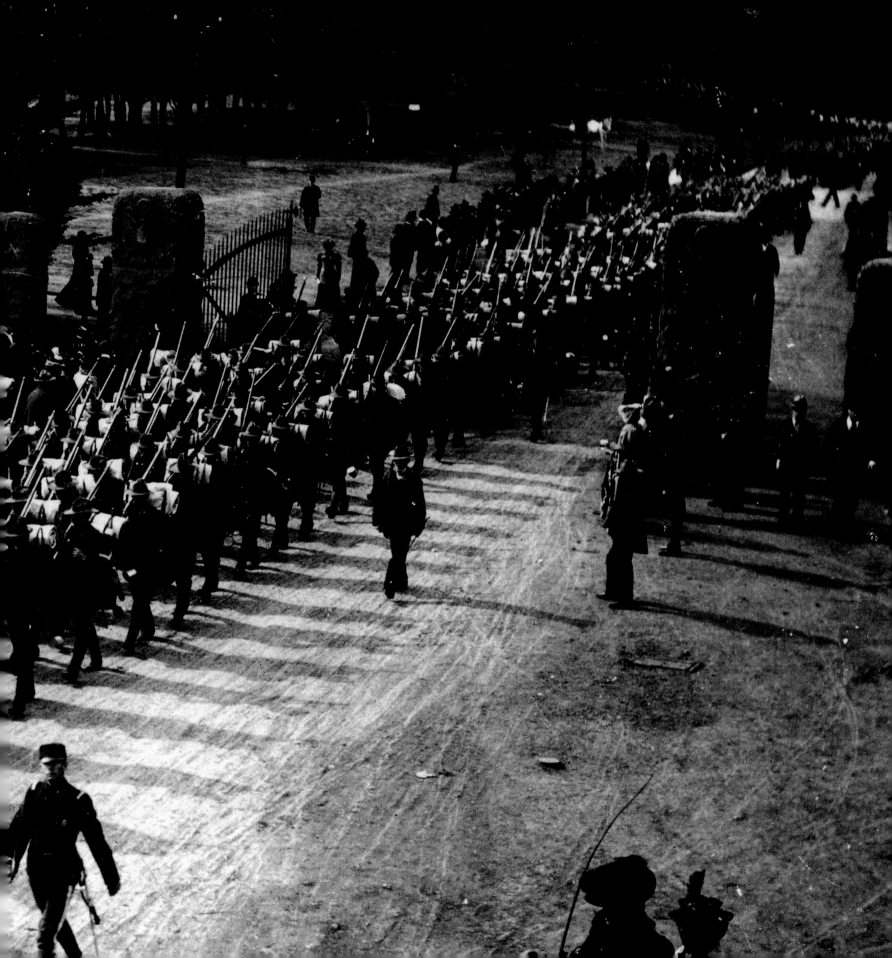

Letterman became the nation's largest debarkation hospital, handling thousands of wounded and sick from the Pacific campaigns. Both the Korean and Vietnam conflicts brought increased troop strength to the Presidio, as well as large numbers of battle casualties to Letterman Hospital. However, the needs of the American military steadily changed over the decades. Between 1945 and 1970, Presidio army activity to support coastal defense declined sharply and the possibility of closing the post or converting it to non-military uses was already under consideration. Various interests began to look upon the Presidio's natural assets and recognize that there were better uses for the 1,480-acre headlands overlooking one of the most beautiful bays in the world than as sites for gun emplacements. In 1972, Congressional legislation was passed, mandating the transfer of the Presidio from the

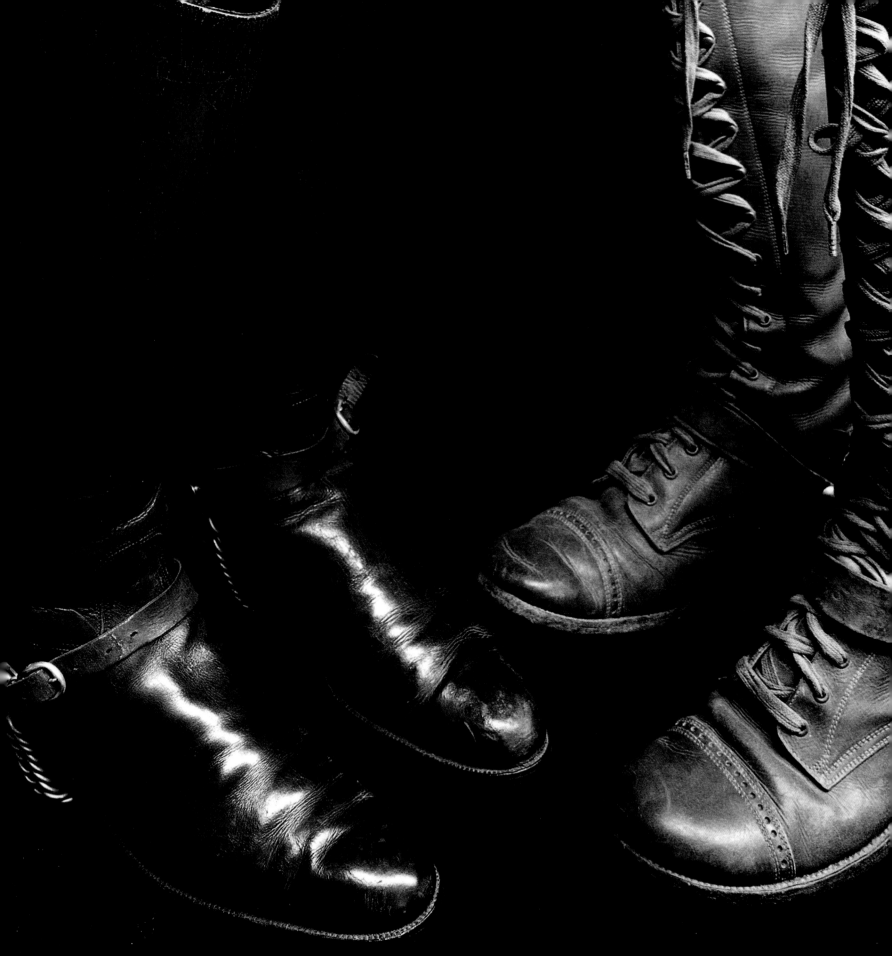

Department of Defense to the National Park Service at some point in the future. Then, in 1989, Congress named the Presidio as one of the bases to be closed as part of the program to reduce the number of military facilities across the United States. With that action, the "future" had arrived, and the conversion process began. It concluded on October 1, 1994, with the formal transfer of responsibility to the National Park Service's Golden Gate National Recreation Area. Featuring breathtaking vistas, verdant open spaces, miles of biking and hiking trails, and a fascinating

Martin bombers flew in formation over the Golden Gate, ca. 1930.

array of historic architecture, the Presidio has attracted millions of visitors from around the world for generations. Its park-like ambiance has made it one of San Francisco's key attractions. **W**hile the Presidio's aesthetic, historical, and cultural

Before the Presidio undertook a major tree-planting beautification program in the 1880s, a barren, windswept landscape marked the military outpost. The few scrub oaks that dotted the grounds had long ago been cut down for fuel and, according to one quartermaster, "scarcely a tree was left behind for ornament or use."

perspectives are invaluable, its role as an ecological preserve is equally so. Standing at the edge of the Oregon and California biological provinces, the Presidio is notable as the site of the earliest scientific recordings of a number of West Coast native species. Lobos Creek, the last stream in San Francisco to flow free, protects valuable

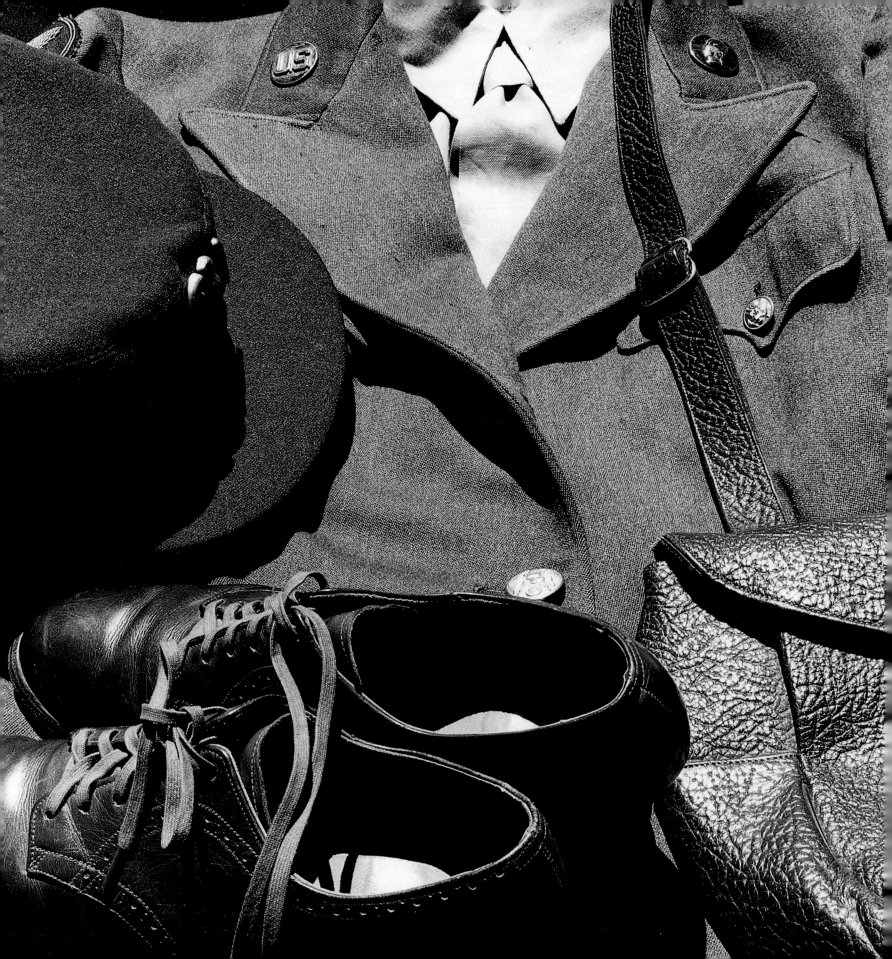

remnants of native riparian habitat, and the post itself is a critical stop for migrating Central and South American birds and butterflies. Several rare plant communities that have disappeared in the rest of San Francisco survive within Presidio boundaries. The United Nations recently reinforced this significance by including the Presidio's diverse ecosystem on a list of areas within a new International Biosphere Reserve. With its transfer to the National Park Service, the Presidio is rededicated to fostering awareness of our global environmental interdependence. As the country's foremost urban national park and environmental study center, the Presidio, with its accessibility to the cultural and ethnic richness of the San Francisco Bay Area, nurtures a wider agenda—one that provides greater public access to the Presidio's open spaces and historic landmarks and promotes appreciation for the beauty and diversity of the ecological community that supports and surrounds us.

North Gate

1 GOLDEN GATE BRIDGE
A 1.2-mile suspension bridge built in 1937 to connect San Francisco to Marin County.

2 GOLDEN GATE HEADLANDS
Site of "El Castillo de San Joaquin," the original Spanish outpost constructed in 1794.

3 FORT POINT
Pre-Civil War brick fortress built to protect San Francisco and the bay.

4 GOLDEN GATE PROMENADE
A pathway for runners and walkers leading through the Presidio from the Marina Green to Fort Point.

5 PILOTS' HOUSES
Built for Crissy Field pilots in 1921.

6 DOYLE DRIVE
Major thoroughfare connecting the city and the Golden Gate Bridge.

7 FORT WINFIELD SCOTT
Established as a separate post in 1912 to man the coastal defense batteries.

8 CAVALRY BARRACKS AND STABLES
Last stable complex constructed prior to the army's substitution of motor vehicles for animal transport.

9 COAST GUARD STATION
A cluster of historic bayfront buildings, including a Dutch Colonial coast guard keeper's residence dating to 1899.

10 CRISSY FIELD
Army airfield used from 1919 to 1936, now a spectacular bayfront park with dunes, beach, shorebirds, and rare grasses.

11 SAN FRANCISCO NATIONAL MILITARY CEMETERY
A 28-acre burial ground designated a national cemetery in 1884.

12 PET CEMETERY
A graveyard for pets of Presidio families.

13 LOG CABIN
Works Progress Administration-era (WPA) recreation center at Fort Scott.

South Gate

14 PRESIDIO GATE
The entrance from Presidio Avenue into the park.

15 TENNESSEE HOLLOW
Military housing in a glen named for the First Tennessee Volunteer Regiment which camped there in 1898.

16 PRESIDIO WALL
Marks the southern and eastern boundaries of the Presidio.

17 FUNSTON AVENUE
A row of Victorian officers' quarters where Tennessee Hollow meets the Main Post.

18 PRESIDIO FOREST
400,000 trees planted in the 1880s to crown the Presidio's ridges and border its boundaries.

19 U.S. PUBLIC HEALTH SERVICE HOSPITAL
Six-story brick hospital and residences built in the 1930s and closed in 1981.

20 MOUNTAIN LAKE
Campsite of the initial Spanish scouting party in 1776, now site of a municipal park.

21 JULIUS KAHN PLAYGROUND
A municipal playground serving military and civilian families since 1923.

22 ECOLOGY TRAIL
A two-mile loop through the Presidio's forest and grassy meadows.

23 GOLF COURSE
One of the earliest golf courses in the West, established in 1895.

24 EL POLIN SPRING
A freshwater spring which Ohlone Indian legend associated with fertility.

25 INSPIRATION POINT
Scenic views of the bay and Presidio looking east.

26 ARGUELLO GATE
Park entrance from Arguello Boulevard.

27 ROB HILL
Highest point in the Presidio and site of a group camping area nestled in the Presidio forest.

East Gate

28 LOMBARD GATE
Long the city's point of entry to the army garrison.

29 MAIN POST
Heart of the Presidio, featuring military architecture spanning more than 200 years.

30 POST THEATRE
Spanish Colonial-style building featuring an arcaded entry pavilion.

31 INFANTRY TERRACE
A row of nearly identical houses built in 1910 for officers of the 30th Infantry and their families.

32 MONTGOMERY STREET BARRACKS
Row of Colonial Revival-style buildings, built in the late 1890s.

33 SIXTH U.S. ARMY HEADQUARTERS
1940s WPA-funded building, now headquarters of the Sixth U.S. Army.

34 PRESIDIO MUSEUM
Spanish history, seacoast artillery, 1906 earthquake, army uniforms and more.

35 LETTERMAN HOSPITAL COMPLEX
Site of the first army general hospital, now a complex of medical facilities and associated administrative and residential buildings.

36 PARADE GROUND AT THE MAIN POST
Scene of daily drills and military pageantry for Presidio soldiers.

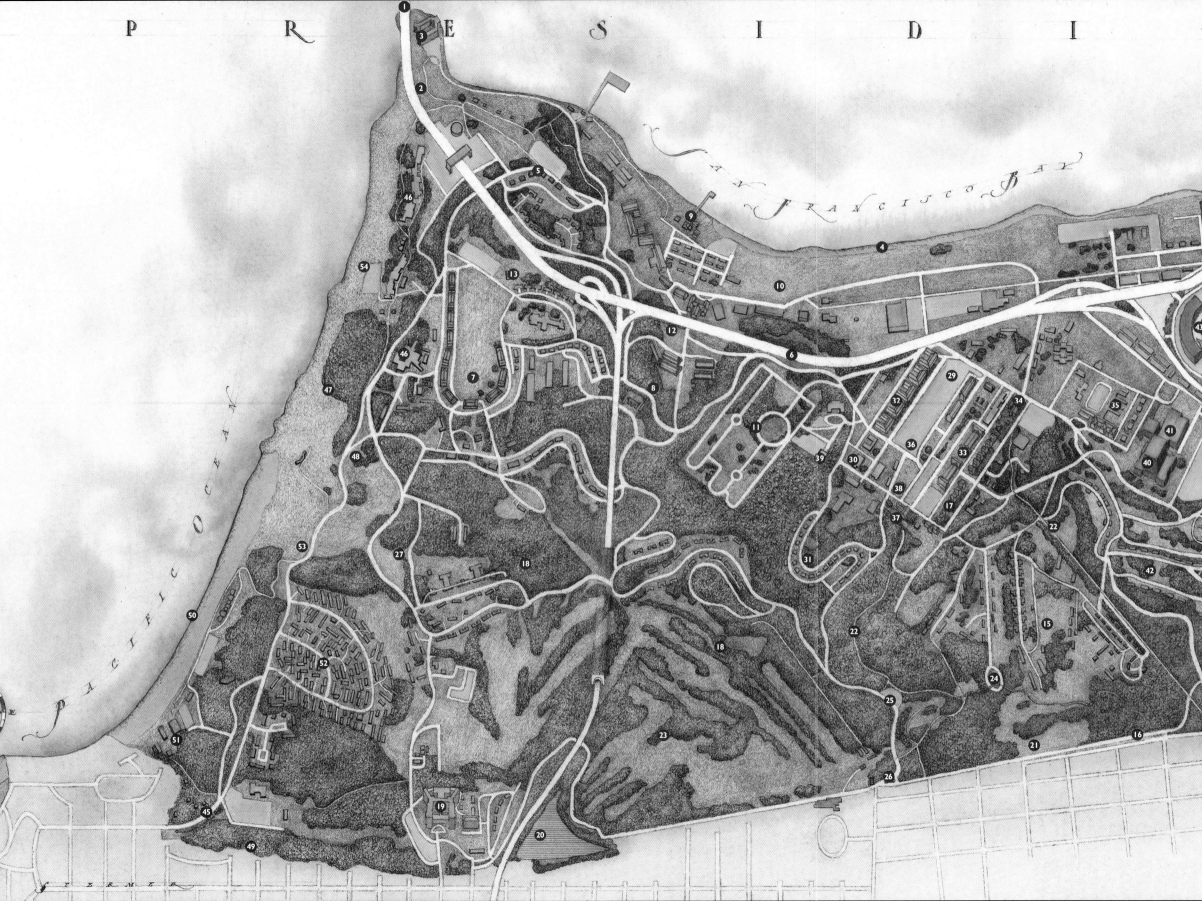

P R E S I D I O

San Francisco Bay

Pacific Ocean

37 *OFFICERS' CLUB*
*Spanish Colonial-style building
containing remnants of a
Spanish-era adobe wall dating
to the late 1700s.*

38 *PERSHING SQUARE*
*Named for John "Black Jack"
Pershing, the World War I
general whose home on the
Presidio was located in the flag-
pole area near the parade ground.*

39 *POST CHAPEL*
*Two-story church in the Spanish
Colonial Revival-style completed
by the WPA in 1932, contains
a large interior mural entitled
"The Peacetime Activities
of the Army."*

40 *LETTERMAN HOSPITAL*
*Ten-story health care facility
which has served military person-
nel, their families, and retirees.*

41 *LETTERMAN ARMY
INSTITUTE OF RESEARCH*
*356,000-square-foot medical
research facility constructed
between 1974 and 1982, fea-
turing laboratory space, offices,
a library, and 300-seat theater.*

42 *SIMONDS LOOP*
*Officers' family housing facing
San Francisco Bay.*

43 *PALACE OF FINE ARTS*
*Built for the Panama-Pacific
International Exposition of 1915,
just outside the Presidio's border.*

44 *MARINA ENTRANCE*
*Marina Boulevard entrance
to the park.*

WEST GATE

45 *LINCOLN BOULEVARD*
*Street leading into the Presidio
from Sea Cliff district.*

46 *COASTAL DEFENSE
BATTERIES*
*Six generations of coastal defenses
along the Presidio's cliffs.*

47 *COASTAL BLUFFS*
*Native habitat, rare plants
and spectacular views of the
Pacific Ocean.*

48 *WEST COAST MEMORIAL
TO THE MISSING*
*Honoring World War II
soldiers lost at sea.*

49 *LOBOS CREEK*
*The last free-flowing stream in
San Francisco, providing the
Presidio with most of its fresh water.*

50 *BAKER BEACH*
*An expanse of beach and
coastal dunes just south of the
Golden Gate.*

51 *LOBOS CREEK
PUMP STATION*
*Historic water treatment
plant built in 1910.*

52 *WHERRY HOUSING*
*Military housing area built
in the 1950s.*

53 *COASTAL TRAIL*
*1.5 mile trail through the
serpentine bluffs facing the
Pacific Ocean.*

54 *FORT SCOTT OVERLOOK*
*Spectacular view of the Golden
Gate Bridge, Marin Head-
lands, and the Pacific Ocean.*

A Guide to the Presidio

Established as a Military Post:	*1776*
Number of Acres:	*1,480*
National Historic Landmark Status:	*Designated in 1962*
Native Plant Communities:	*14*
Last Free-flowing Stream in San Francisco:	*Lobos Creek*
Approximate Number of Trees in Presidio Forest:	*400,000*
Highest Point:	*Rob Hill, elevation 384 ft.*
Transfer to National Park Service:	*October 1, 1994*

THE PRESIDIO

North Gate

Literally and metaphorically, the Golden Gate —now symbolized by the majestic sweep of twin bridge towers—is where the Pacific ends and the West begins. The principal portal of western America, the Golden Gate is the drainage for sixteen California rivers and the only major opening along a one thousand mile stretch of coast. **T**his master stroke of nature ensured an enviable commercial prosperity for what would become known as the Bay Area, and was the key reason that the Presidio was established on its southern headlands in 1776. The focal point for much of California's early history, this strategic strait has witnessed the major movements in the West, from Spanish colonists to Gold Rush miners to Asian immigrants.

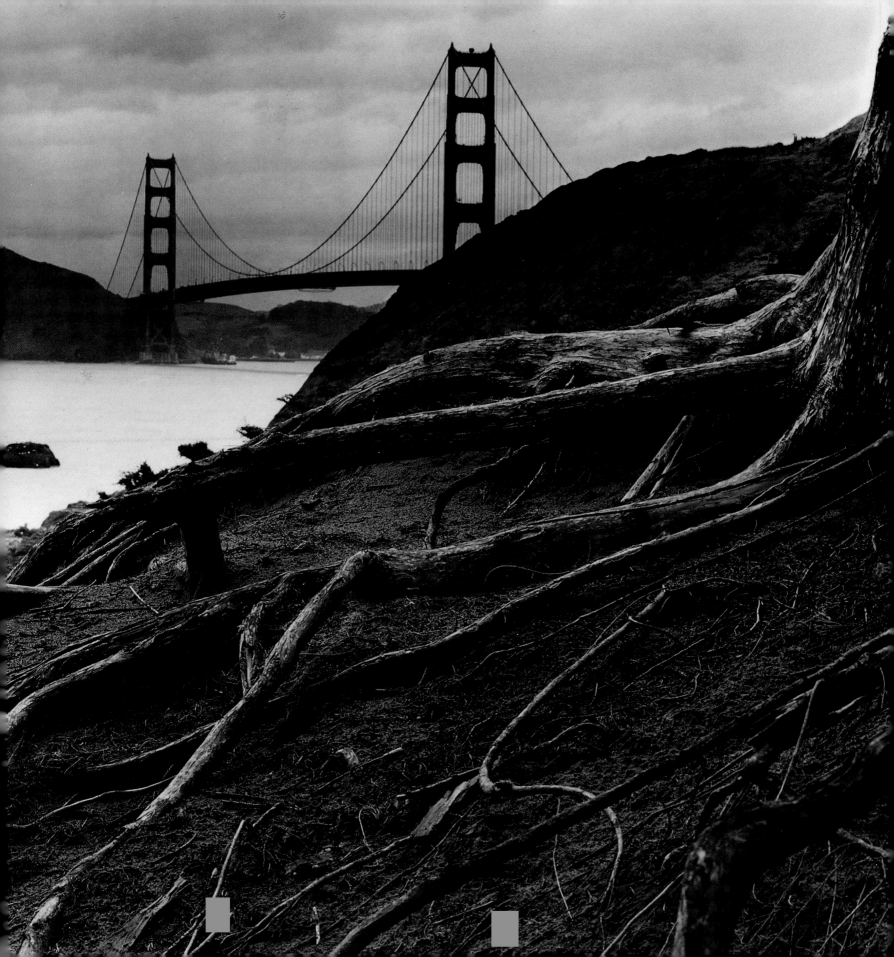

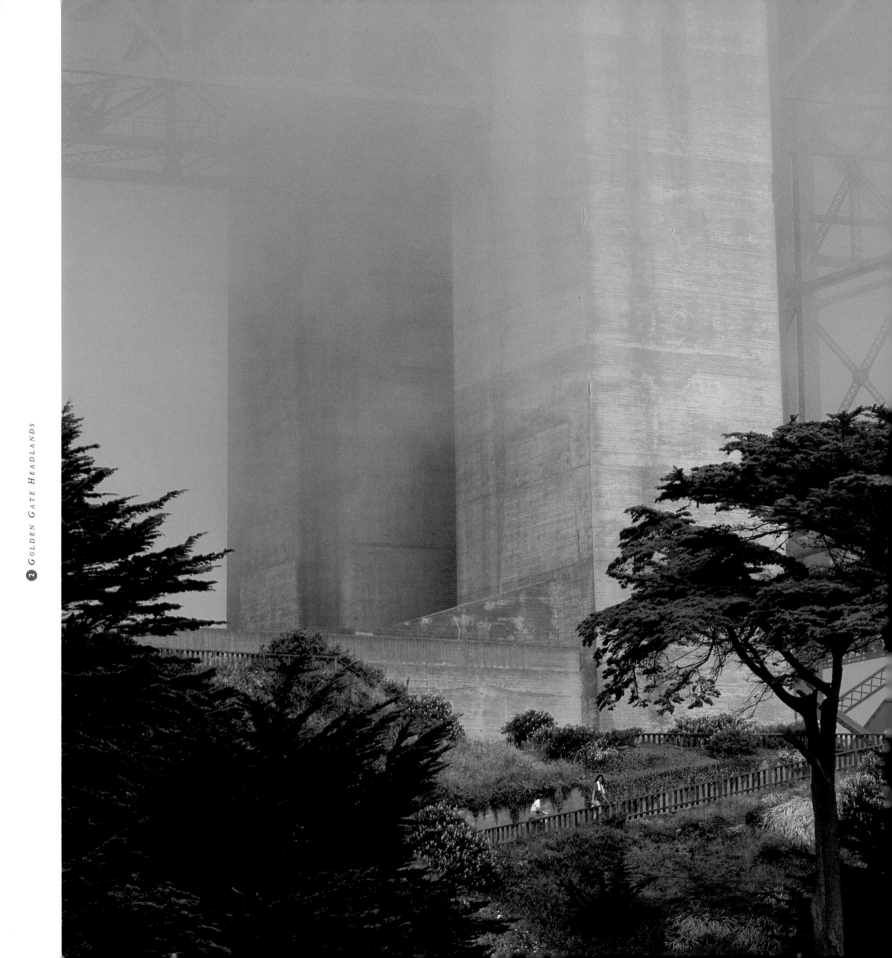

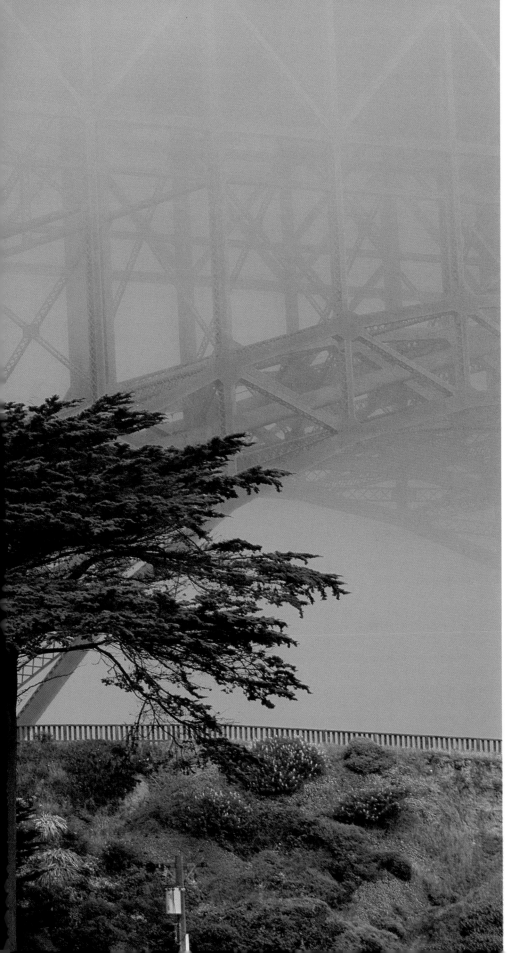

A lighthouse, built in 1855, once stood above the Golden Gate. Two keepers maintained the lantern, which beamed a light visible twelve miles at sea, and kept a 1,000-pound fog bell wound tight. Today the bridge's southern anchorage dominates the view from the old lighthouse keepers' grounds.

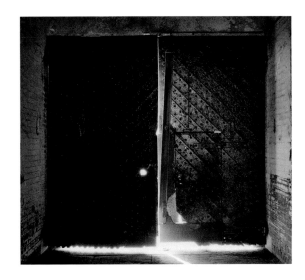

3 *FORT POINT*

These sally port doors lead into Fort Point, constructed in 1853. With one hundred cannon and four hundred men, Fort Point was considered a formidable deterrent against naval attack during the Civil War.

Benches along the Golden Gate
Promenade, the path that
follows the contour of the bay to
Fort Point, invite strollers to sit
awhile and enjoy the view.
Right: The establishment of an Army
Air Service coast defense station in
1919 led to the construction of
Mediterranean Revival-style pilots'
quarters near Crissy Field.

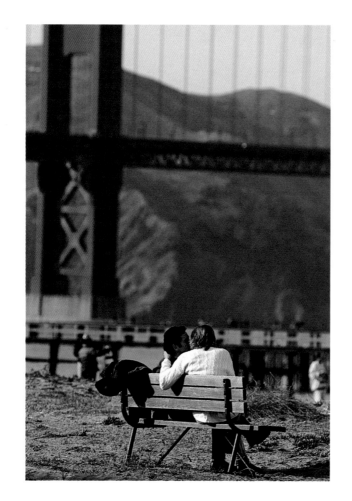

4 GOLDEN GATE PROMENADE

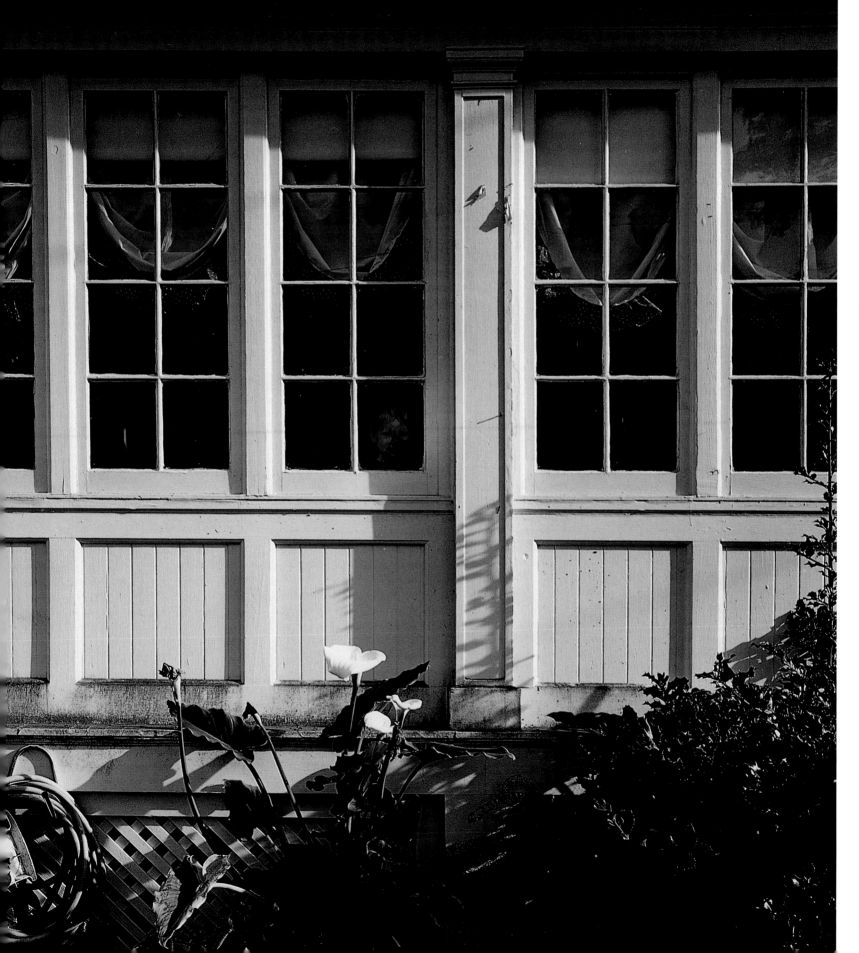

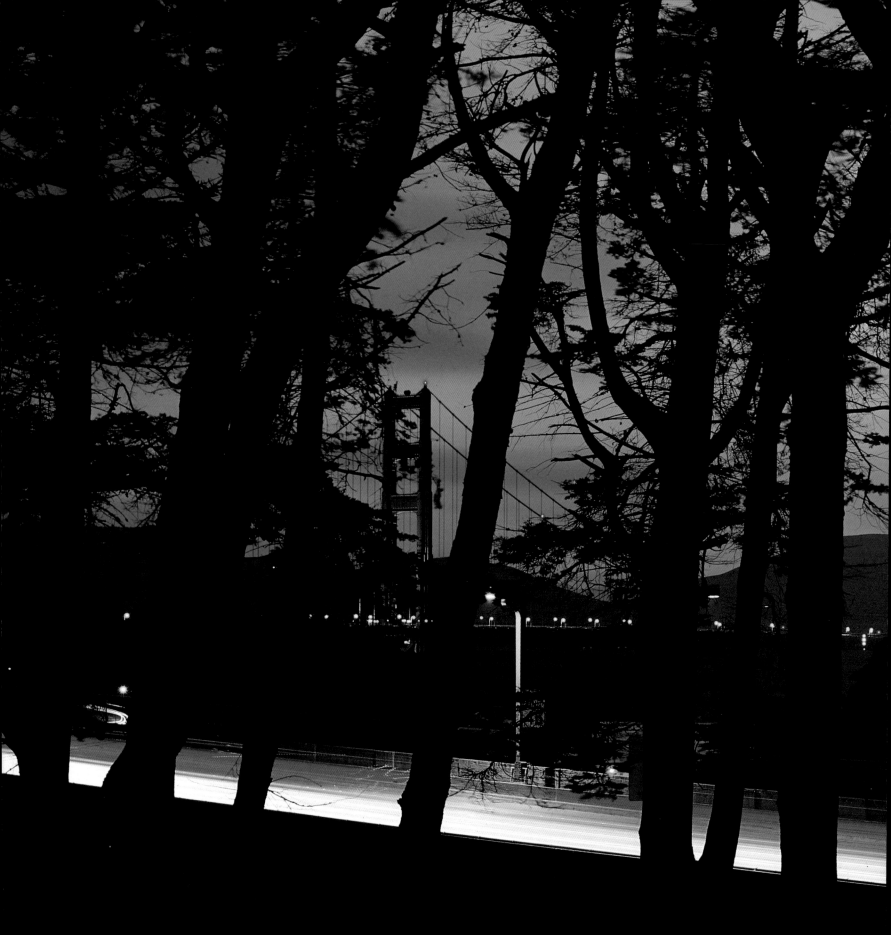

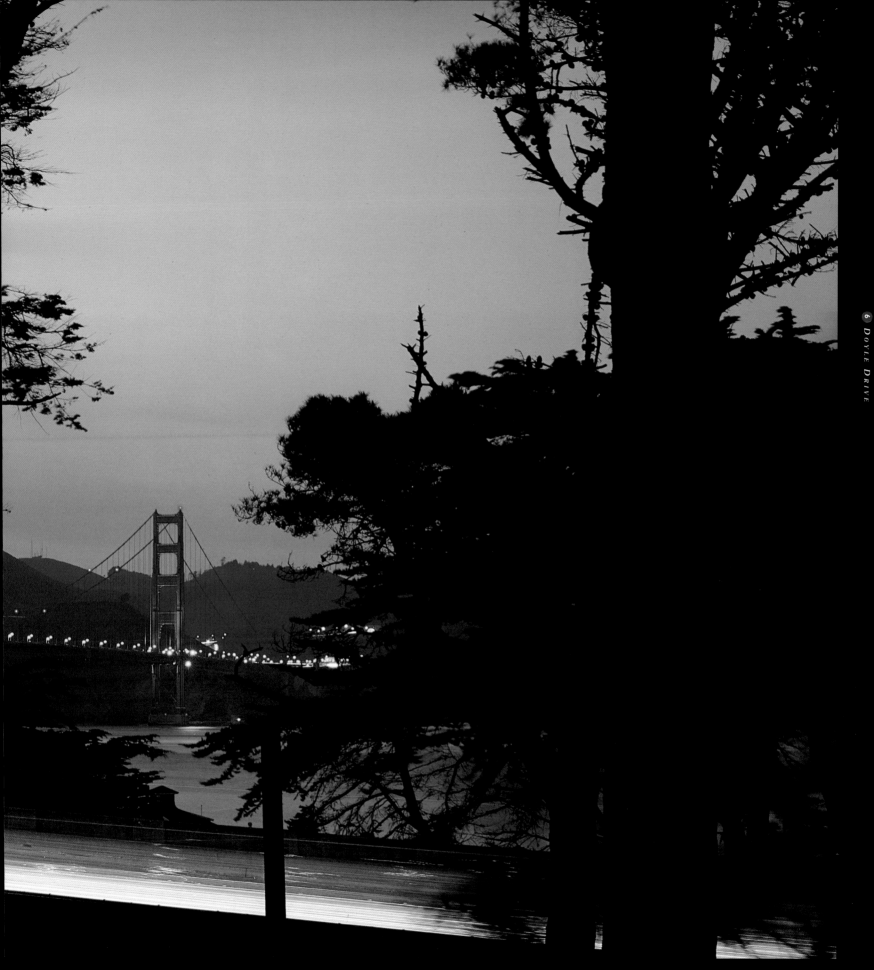

Previous:

Day and night, traffic moves through the Presidio on Doyle Drive, which connects the city to the Golden Gate Bridge.

Below: Fort Winfield Scott was established in 1912 as a separate post for the coast artillery corps, assigned to service the coastal fortifications that extended from Fort Point to Baker Beach. The role of Fort Scott diminished as aircraft carriers moved the coastal defense out to sea.

❼ *FORT WINFIELD SCOTT*

Built in 1902 on a hill overlooking the stables, the old cavalry barracks was converted to other uses when motorized vehicles replaced horses following World War I.

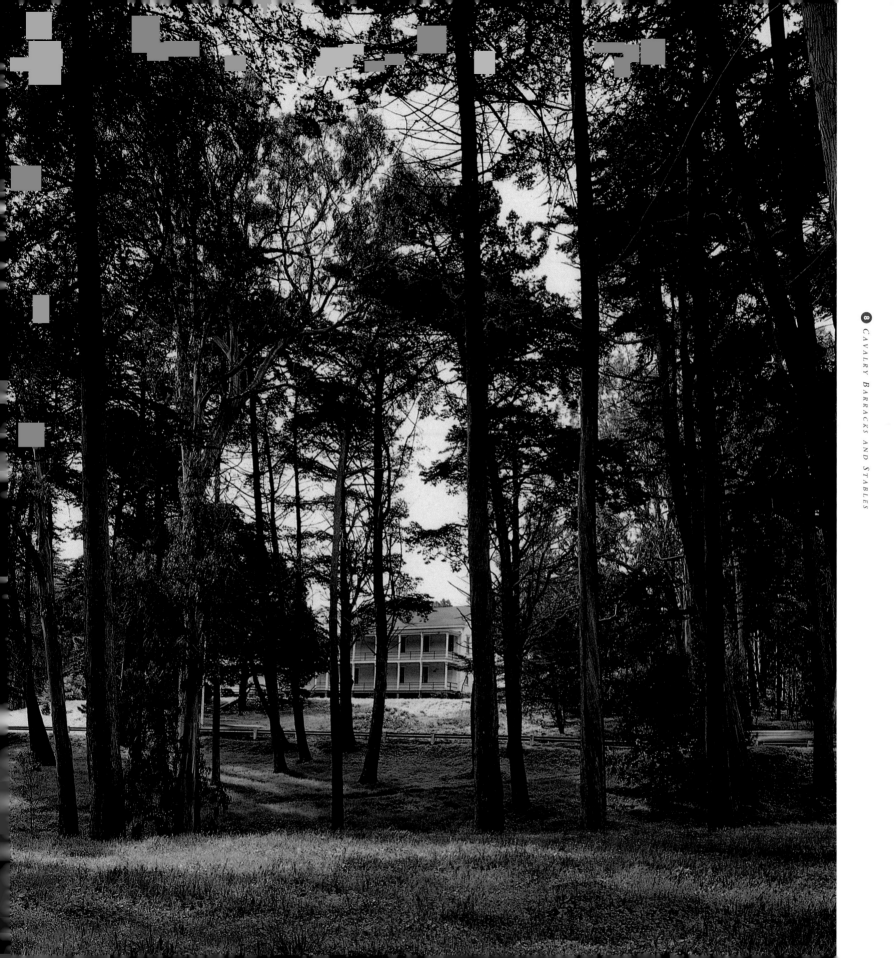

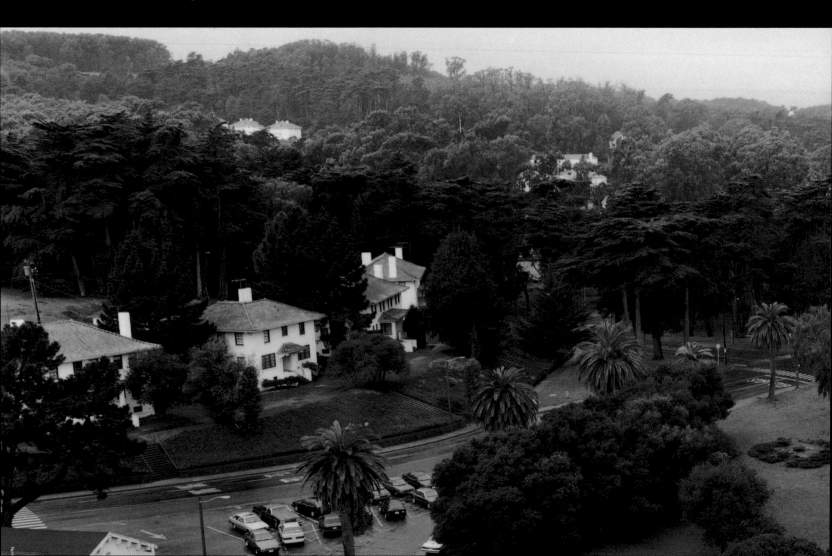

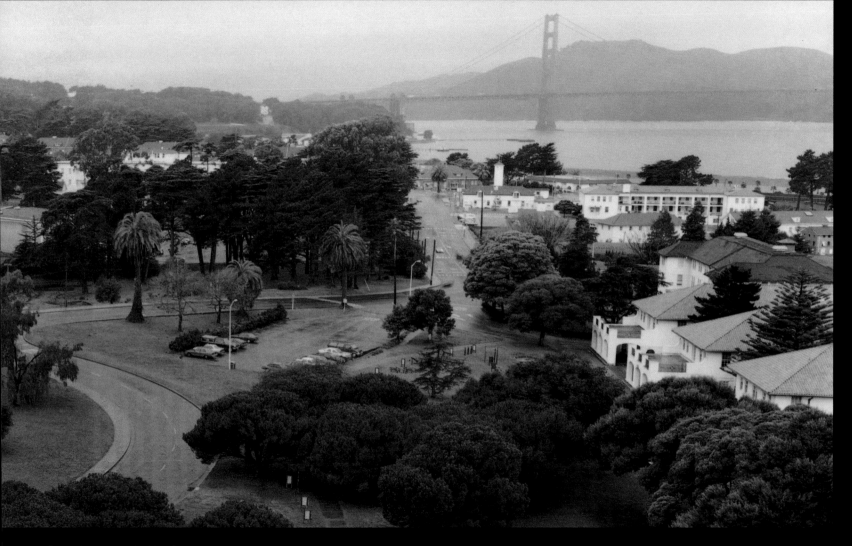

Looking across the Main Post
toward the Golden Gate

Bridge, one sees why the Presidio

B uilt in 1899, the keeper's
residence for the former U.S.
Coast Guard Station is the only Presidio
structure in the Dutch Colonial Revival
style, which typically has a gambrel roof.

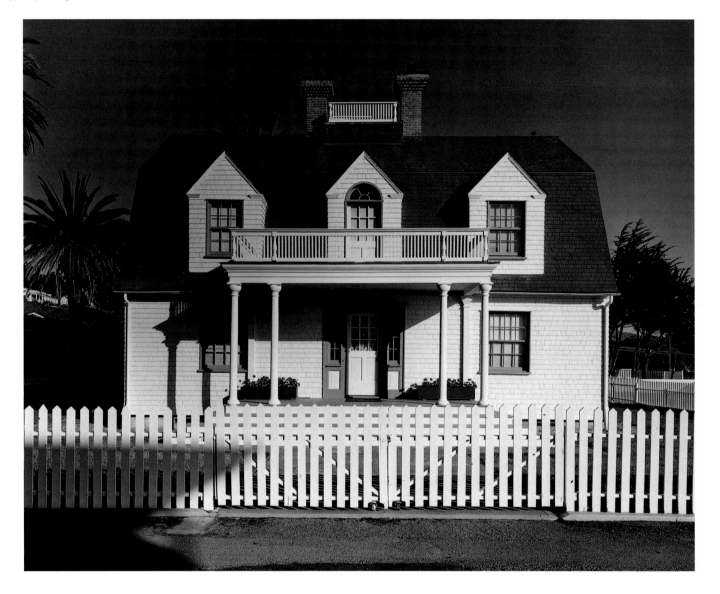

9 *COAST GUARD STATION*

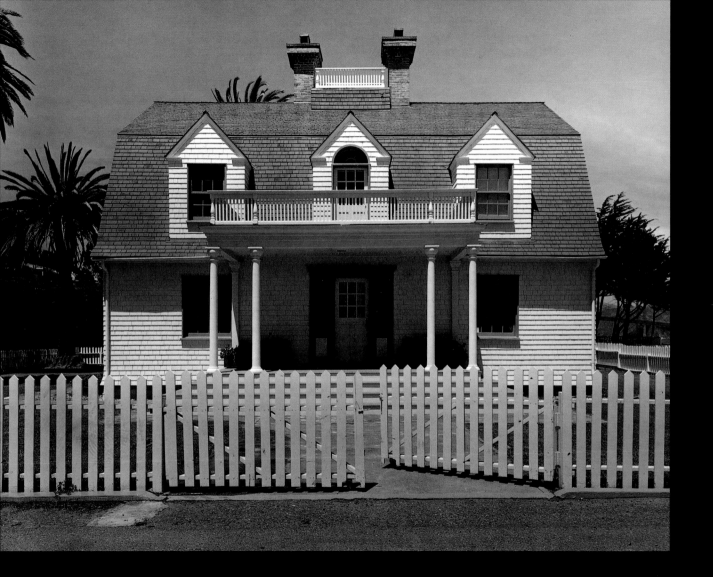

The old house originally stood
seven hundred feet east of its

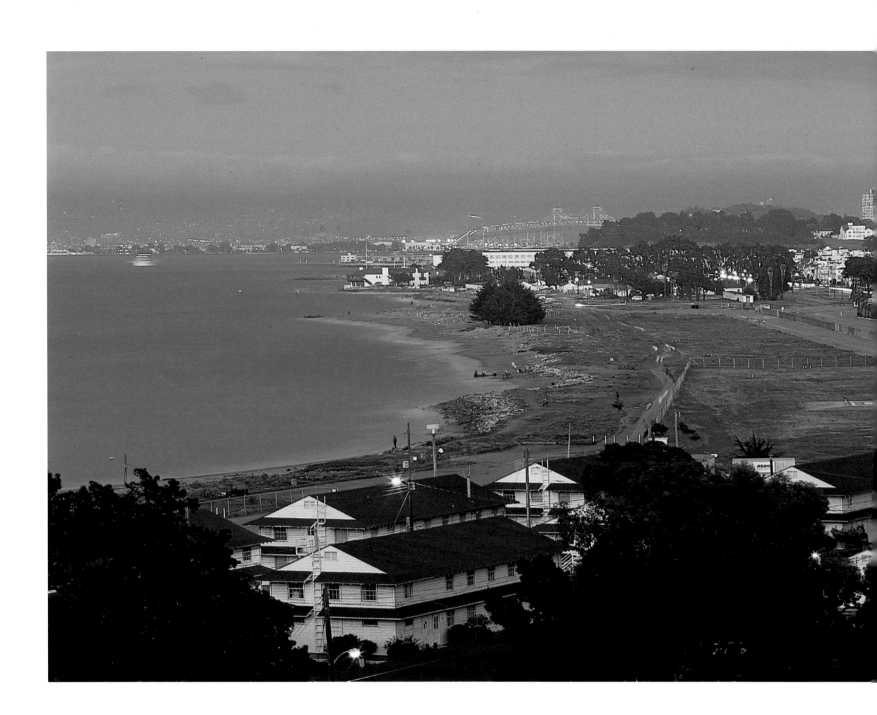

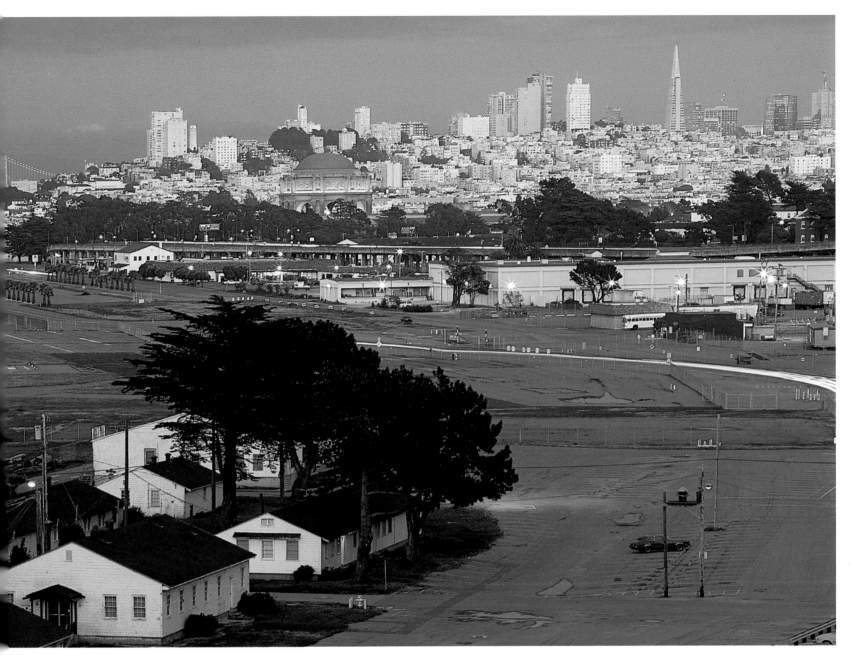

Crissy Field and the city sky-
line are visible from the
overlook near Lincoln Boulevard.
Originally a vast bay marshland,
Crissy Field was filled in to create a
raceway for the Panama-Pacific
International Exposition, a world's
fair honoring the opening of the
Panama Canal and reconstruction of
San Francisco following the 1906
earthquake. After the fair closed, the
army turned the flat land into an air-
field, named in honor of Major Dana
Crissy who was killed during a
transcontinental air race that had
originated in San Francisco.

39

This Mediterranean Revival-style structure was built in 1921 to serve as the guard house for Crissy Field, which was the first and only Army Air Service coast defense station on the West Coast. Limited space, ever-present fog, and the construction of the Golden Gate Bridge led the army to formally close Crissy in 1936.

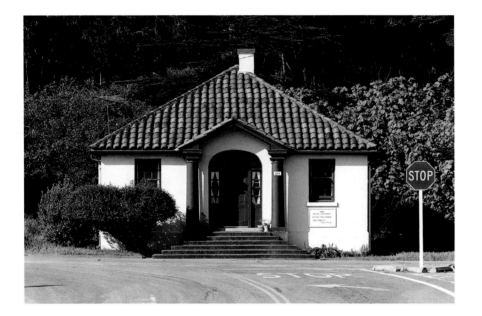

⓾ *CRISSY FIELD*

Established in 1884, the San Francisco National Military Cemetery is the final resting place for fallen soldiers and veterans from the Civil War on, including the remains of many war dead disinterred from abandoned western military posts and moved to the Presidio.

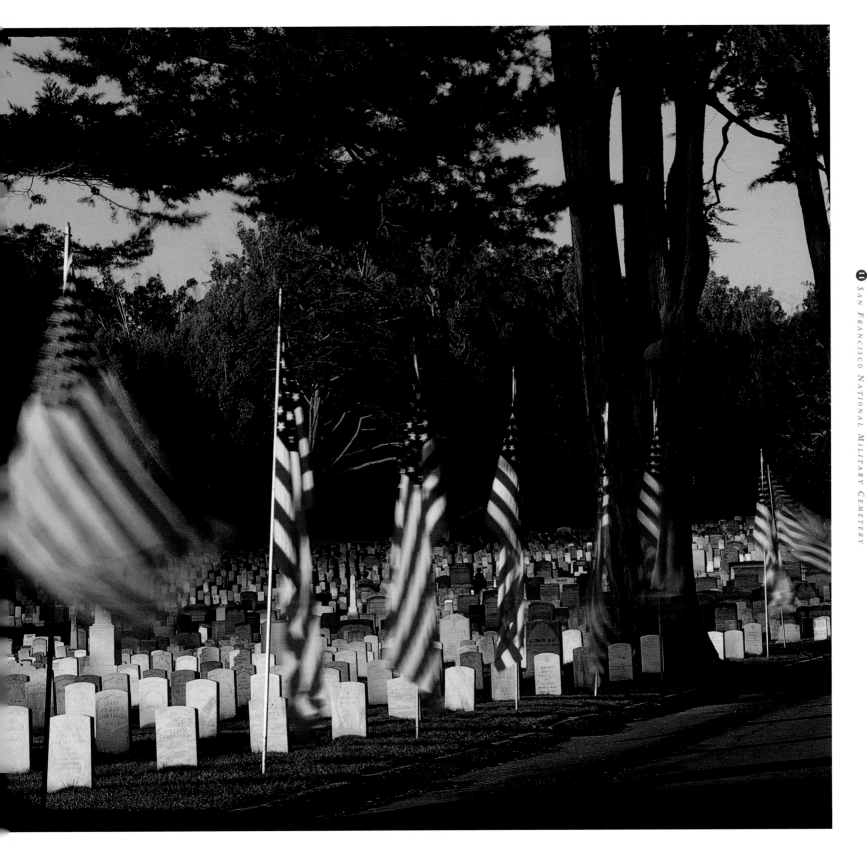

MG P. H. BRADY

1337 POPE STREET

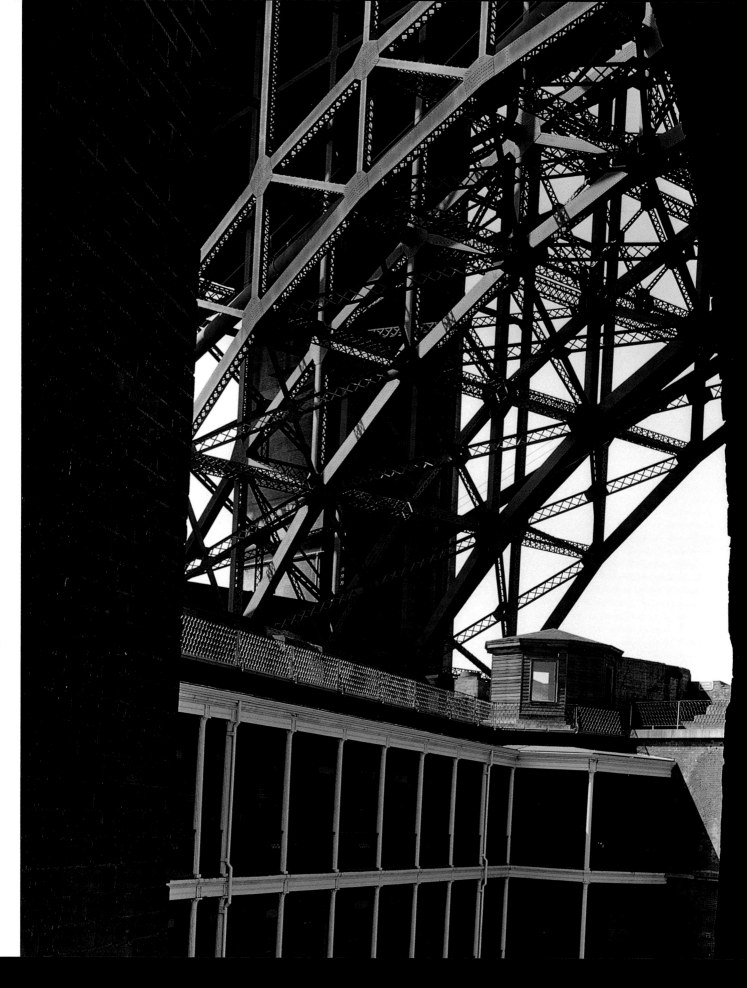

Fort Point stands directly under the southern anchorage of the Golden Gate Bridge. Initially, the abandoned fort was to be razed to make room for the anchorage, but bridge engineers were so impressed by the fort's fine masonry that they designed a steel arch to span the fort and preserve the landmark.

Previous: This Georgian Revival-style home was built in 1915 for the commanding officer of Fort Winfield Scott. After World War II, it became the residence of the deputy commander of the Sixth U.S. Army.

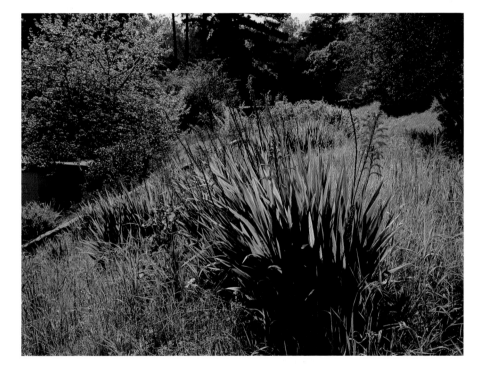

Gardening has traditionally been a popular pastime for Presidio military residents. Today, cultivated plants flourish alongside coastal wildflowers and grasses in the Presidio's open spaces.

nlike the wood and brick buildings that characterize the Main Post, the concrete and stucco structures at Fort Scott *(below and far right)* were largely planned as a unit in the Mission Revival-style, reflecting California's Spanish Colonial history.

⑦ FORT WINFIELD SCOTT

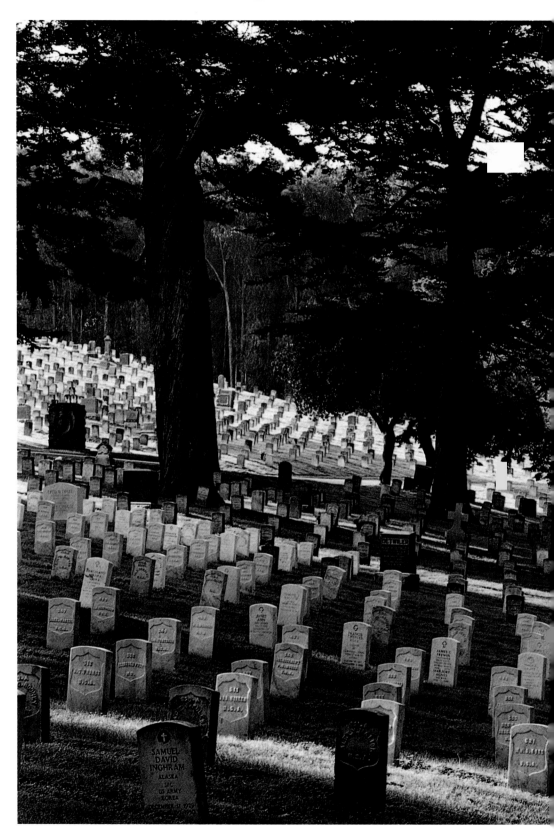

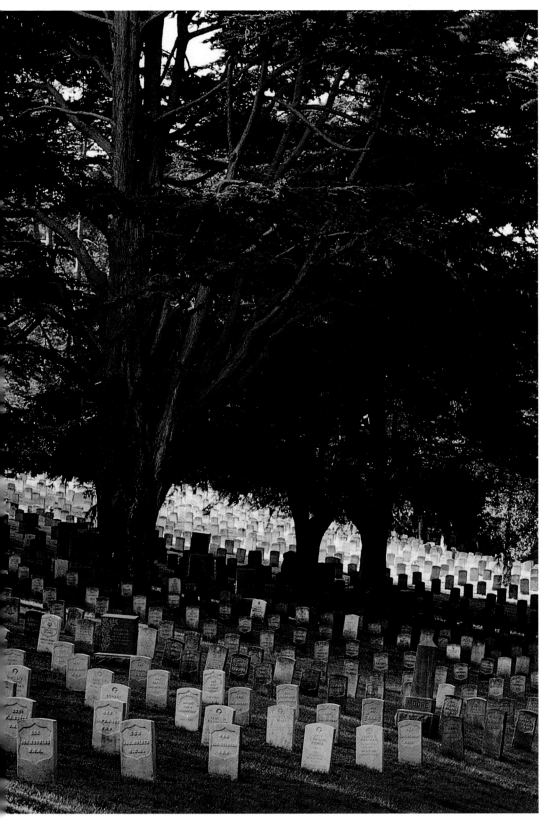

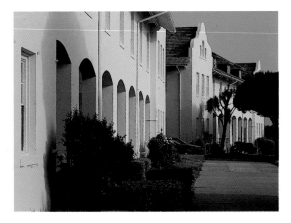

The San Francisco National Military Cemetery is the burial site for many famous individuals, including Pauline Cushman Fryer, a famous Union spy during the Civil War; Major General William "Pecos Bill" Shafter, a Presidio commander from 1896-1897 and Spanish-American War general; Brigadier General Frederick Funston, the army commander who directed the 1906 earthquake relief efforts; and Phillip Burton, the U.S. Congressman who authored the 1972 legislation that created the Golden Gate National Recreation Area.

The porch of the old coast guard keeper's residence looked out over the station's rescue pier. During its century-long stay at the Presidio, the coast guard conducted search and rescue operations, provided navigational aid, and supervised recreational boat safety around the bay.

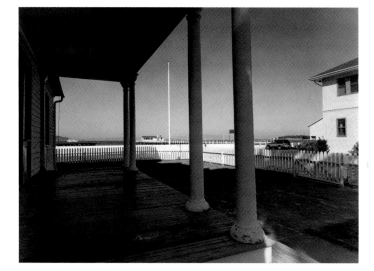

This Mediterranean Revival-style administration building at Crissy Field once housed the offices of Henry H. "Hap" Arnold, who served as the airfield's first commander.

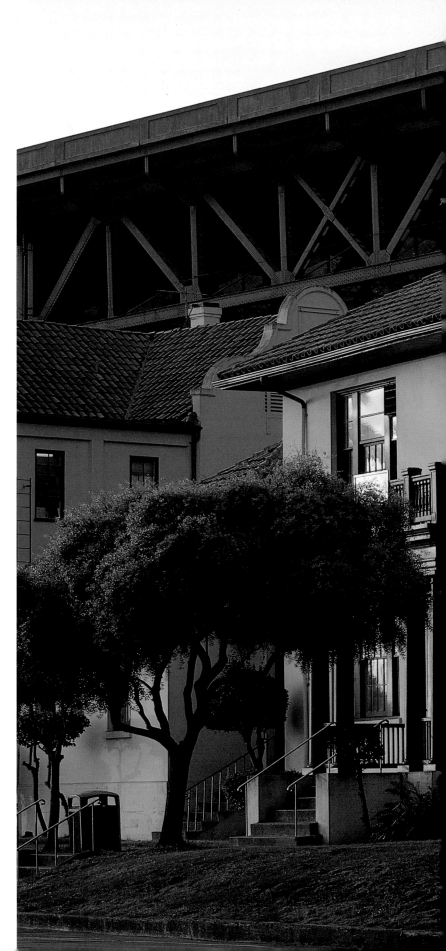

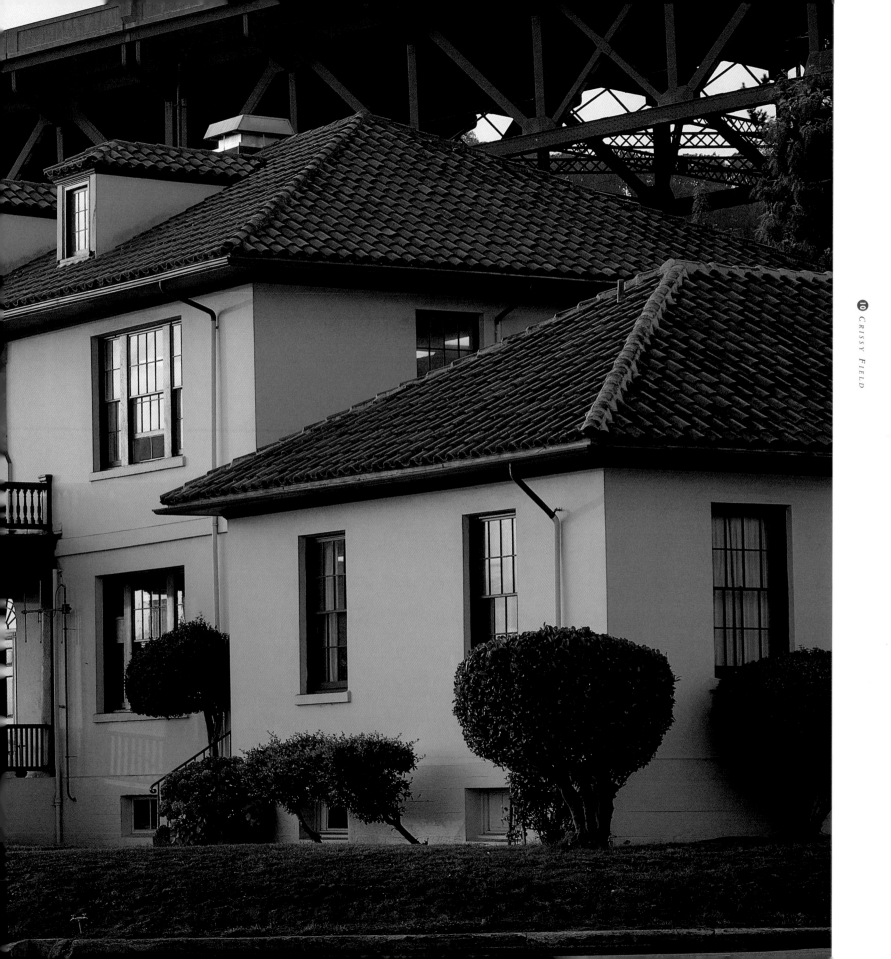

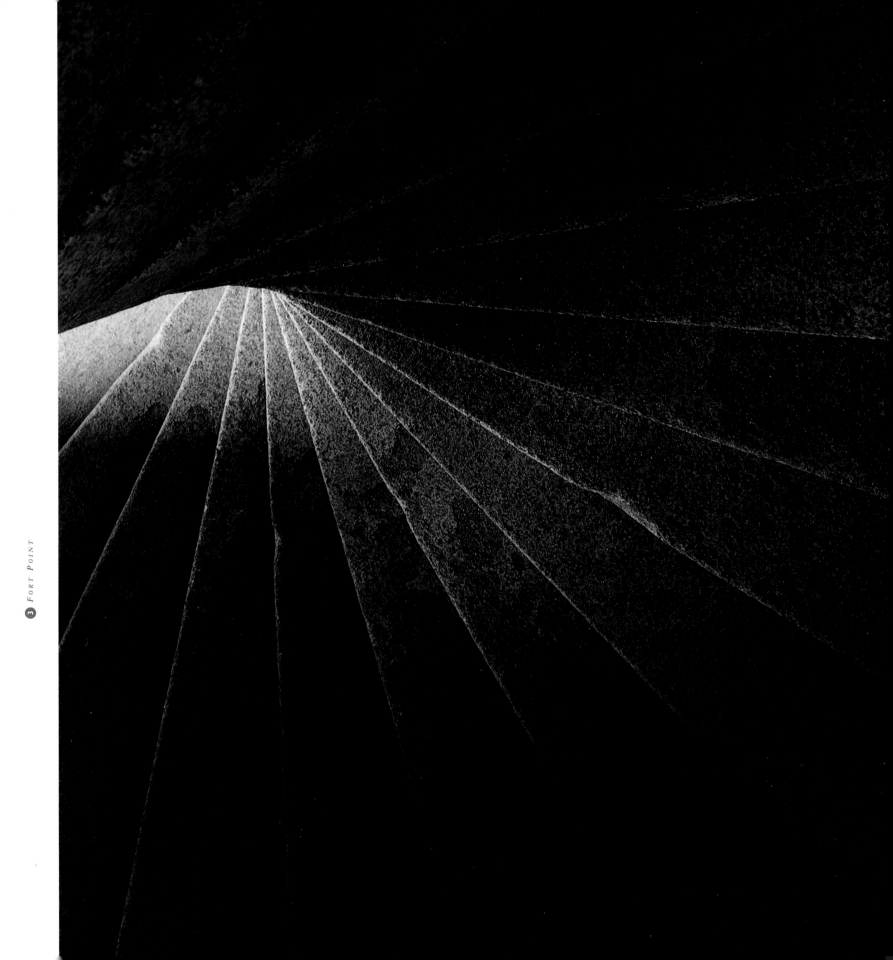

Called the Golden Gate Promenade, the scenic shore-line path from the east end of the Presidio to the bluff above Fort Point is a popular jogging and biking trail.

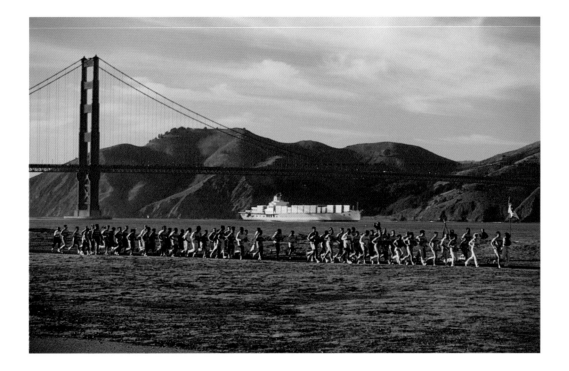

Granite slabs were used to construct three separate free-standing staircases at Fort Point. Each of the sixty-four steps in this staircase weighs about one thousand pounds.

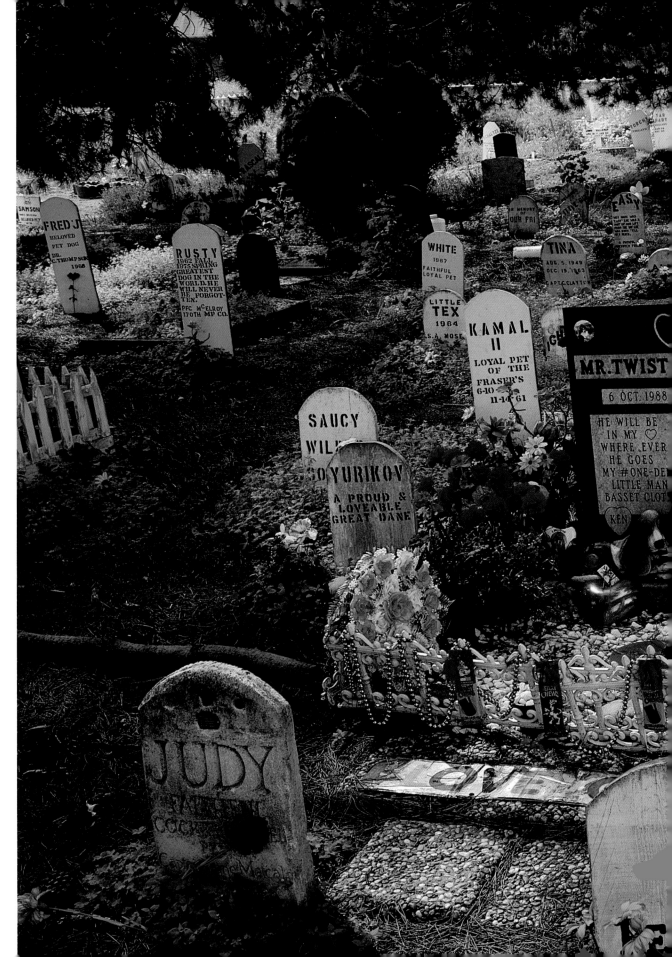

Originally a burial ground for K-9 guard dogs, this small plot, with many tombstones bearing sentimental inscriptions, has been the graveyard for the beloved pets of Presidio families since World War II. Always bedecked with flowers, the tiny cemetery attracts visitors who pause to read gravestone inscriptions such as the one for a pet named Raspberry, which says, "It's true my basset has gone away. I know we had to part. But she'll be with me every-day within my loving heart."

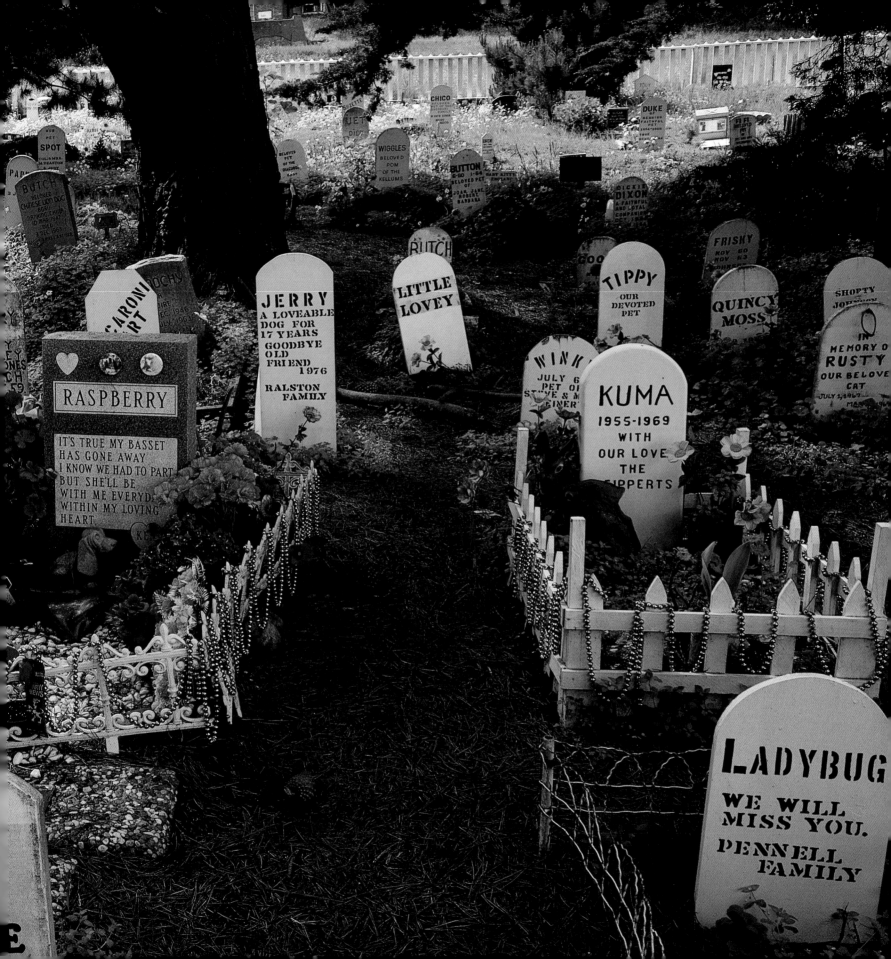

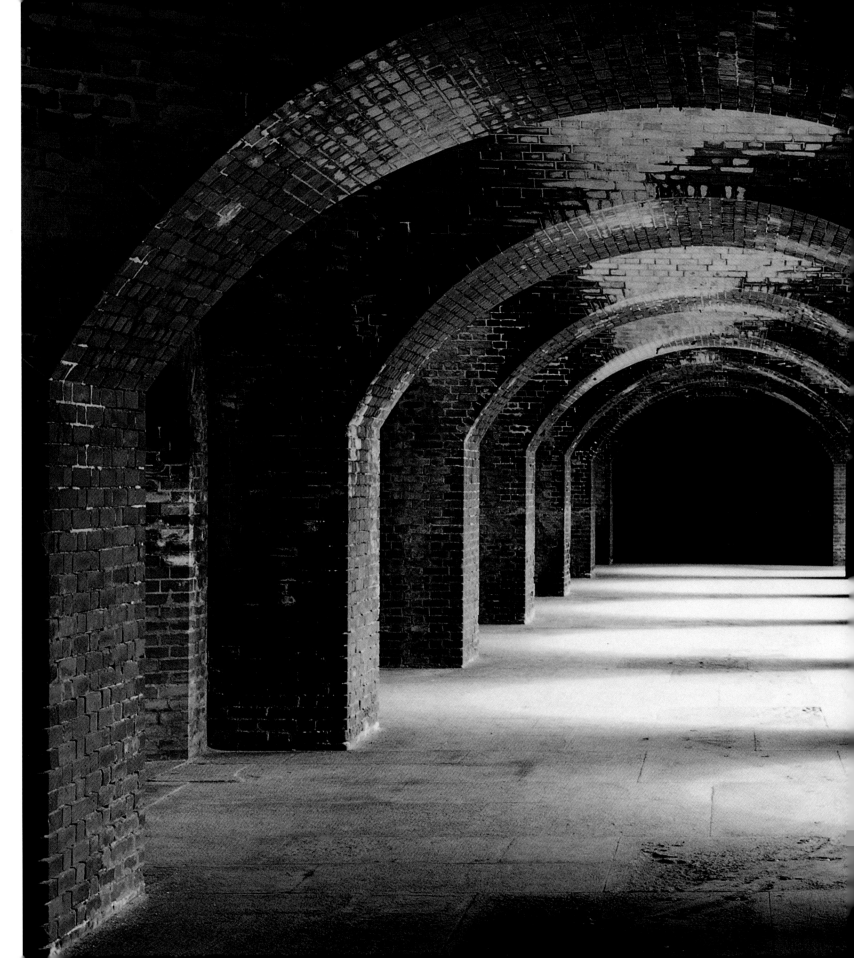

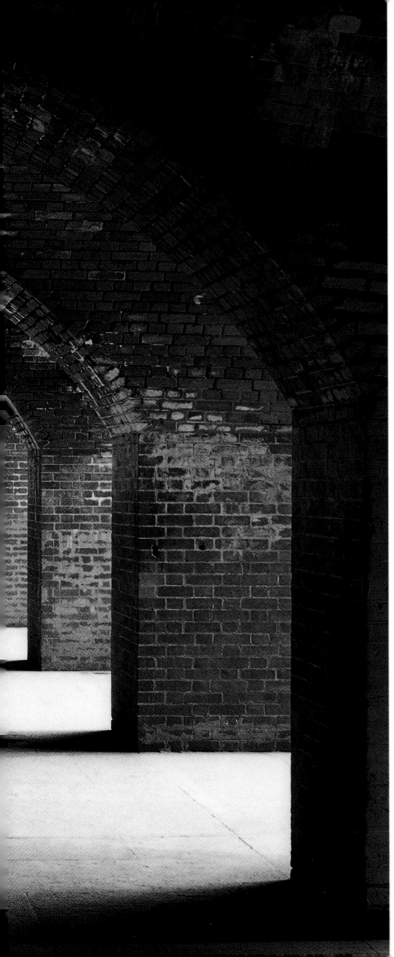

Writing about the new post in 1912, a *San Francisco Call* article predicted: "When the landscape features are completed, Fort Winfield Scott will be the finest, as it is already the most beautifully located, army post in the country."

7 *FORT WINFIELD SCOTT*

In the early 19th century, arched casemates such as these provided a bombardment-proof structure that protected both men and weapons. As a harbor defense post, Fort Point became obsolete following the introduction of new artillery after the Civil War.

THE PRESIDIO
SOUTH GATE

Separated from the residential districts of Pacific Heights and Presidio Heights by only a low stone wall, the Presidio has lived in cooperative harmony with its civilian neighbors to the south. **F**rom the days of Spanish occupation, when a footpath led from the Main Post to Mission Dolores, the Presidio has been considered an open post. The U.S. Army maintained this policy, allowing civilian neighbors to graze cattle on what was initially grassland and taking the formal position in 1874 that the public be allowed to use unoccupied portions of the base for recreation. Even before the turn of the century, the public viewed the Presidio as a unique kind of park, a favorite place for city dwellers to take a Sunday ride. With vista points and hiking trails and bicycle paths that meander through the forest, the Presidio is a setting that all can enjoy.

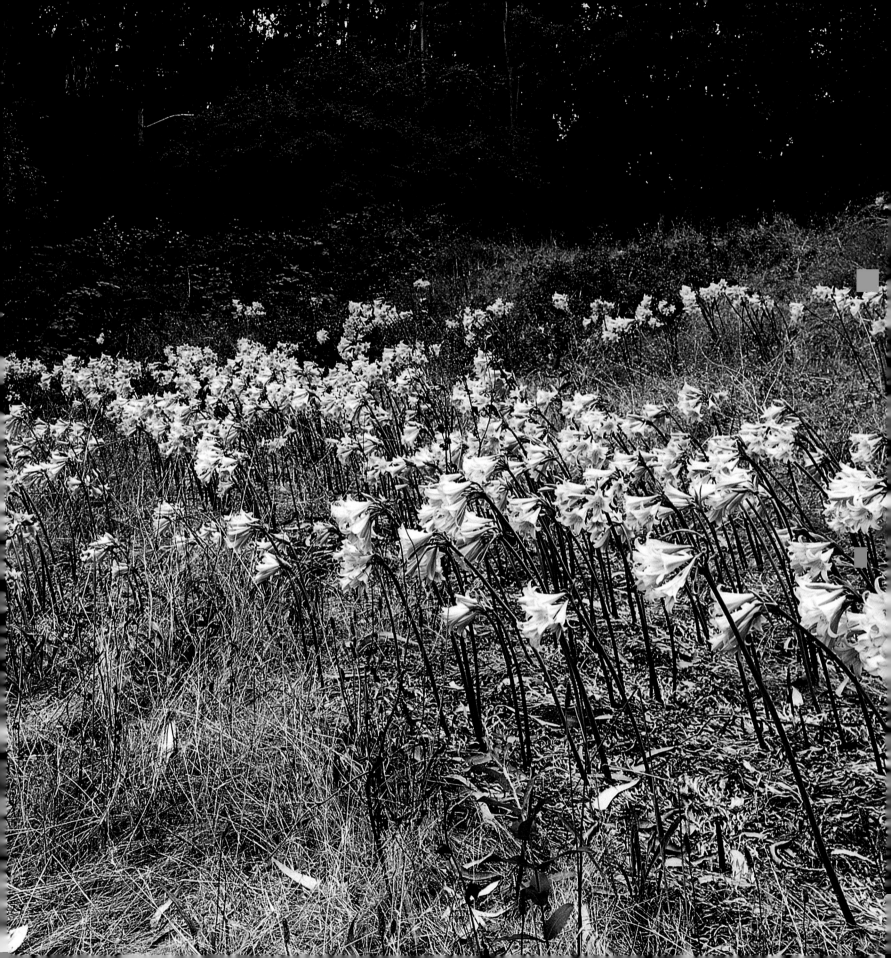

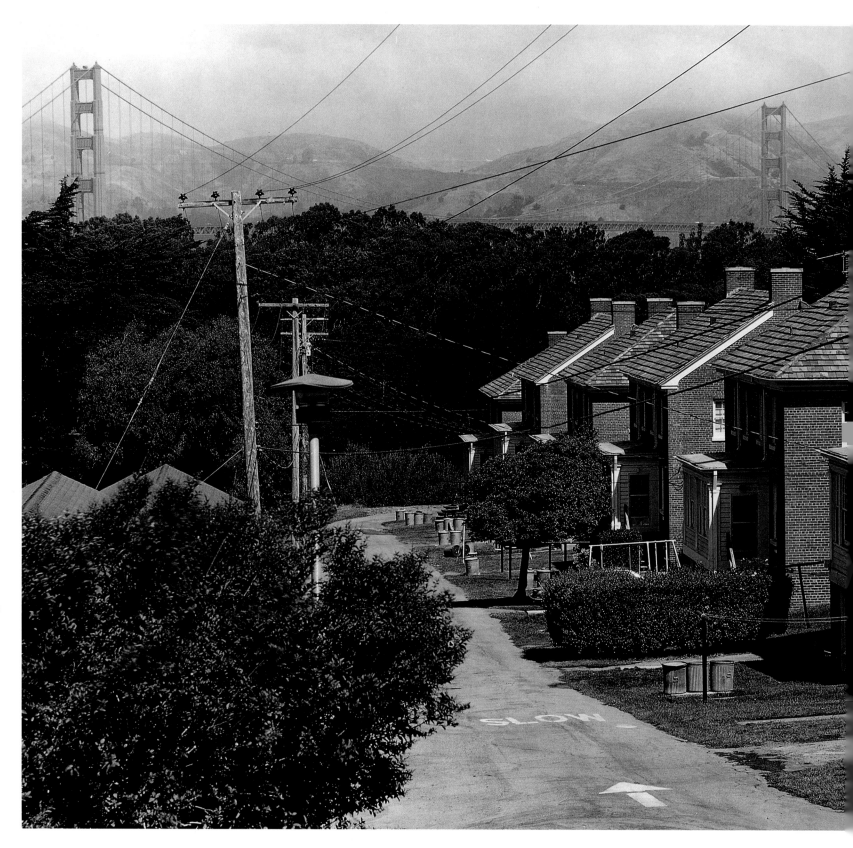

As a primary post on the Pacific Coast, the Presidio was a major marshalling point for troops bound for the Philippines during the Spanish-American War in 1898. The camp site of the First Tennessee Volunteer Regiment near Funston Avenue became known as Tennessee Hollow in its honor.

In the 1930s, the army constructed a neighborhood of Georgian Revival houses there for enlisted men and their families.

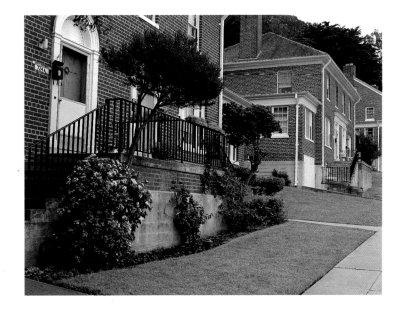

⓯ *TENNESSEE HOLLOW*

Following:

A valley between two ridges crowned by trees, Tennessee Hollow was developed with homes built along the contour of the ridges.

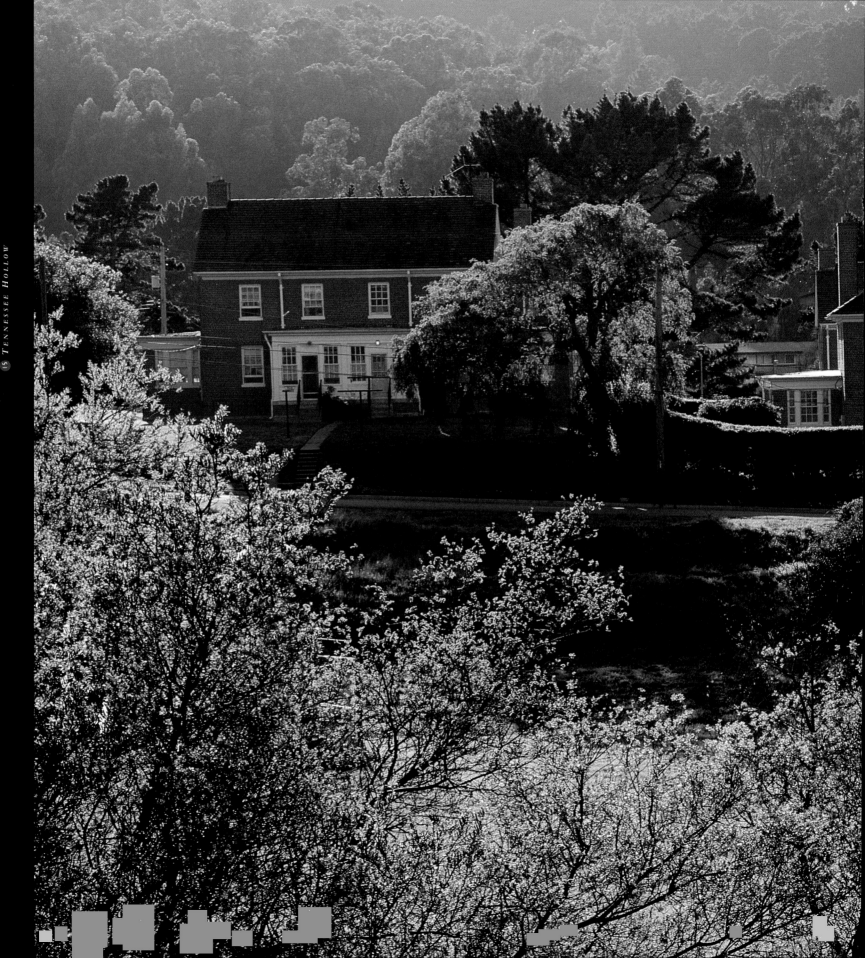

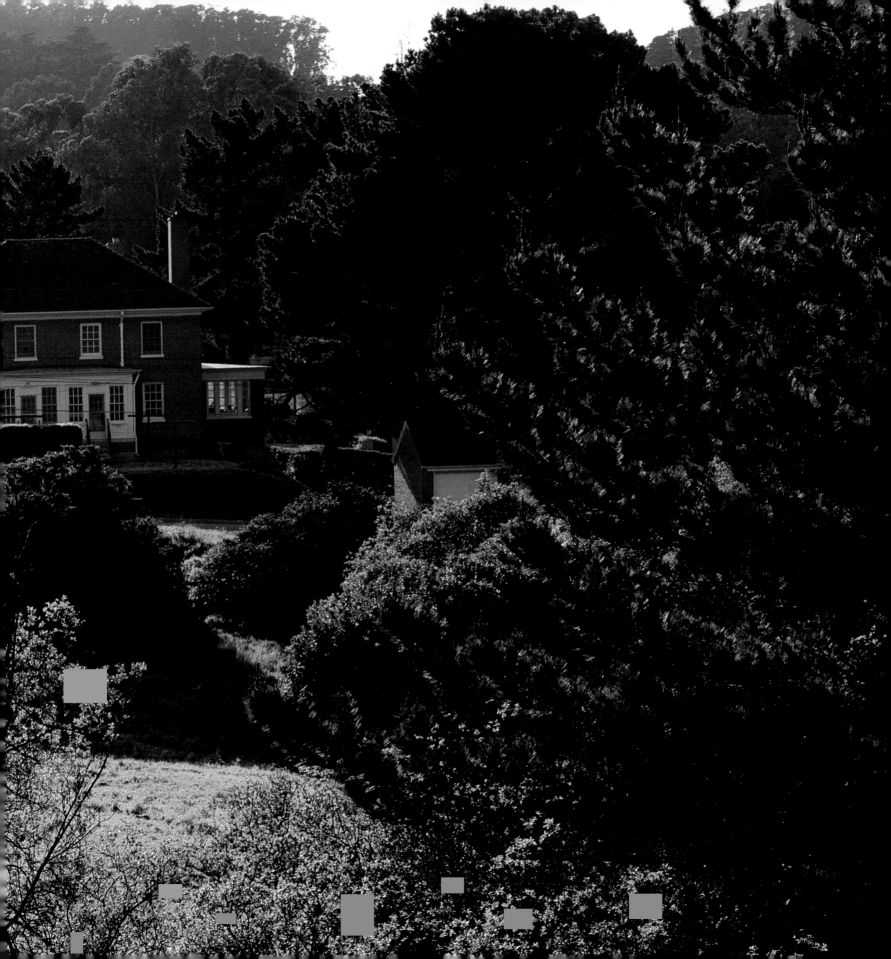

Built in 1885, this former field grade officer's quarters, featuring decorative stick columns, stained glass, enclosed porch, and bay windows, is one of four Queen Anne Stick-style houses near Tennessee Hollow.

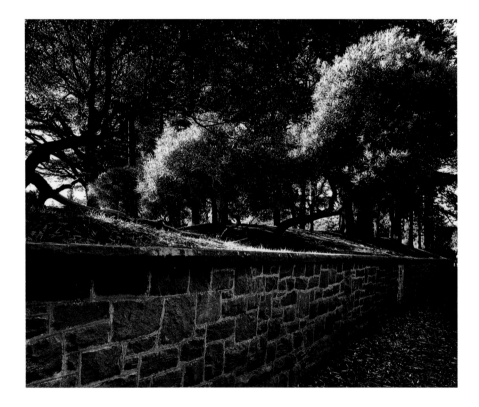

16 *PRESIDIO WALL*

The stone wall that marks the southern and eastern boundaries of the Presidio was constructed by the army between 1895 and 1896, in part to restrict squatters from moving onto the open land.

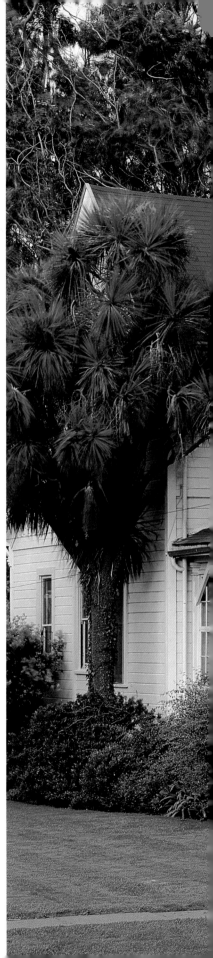

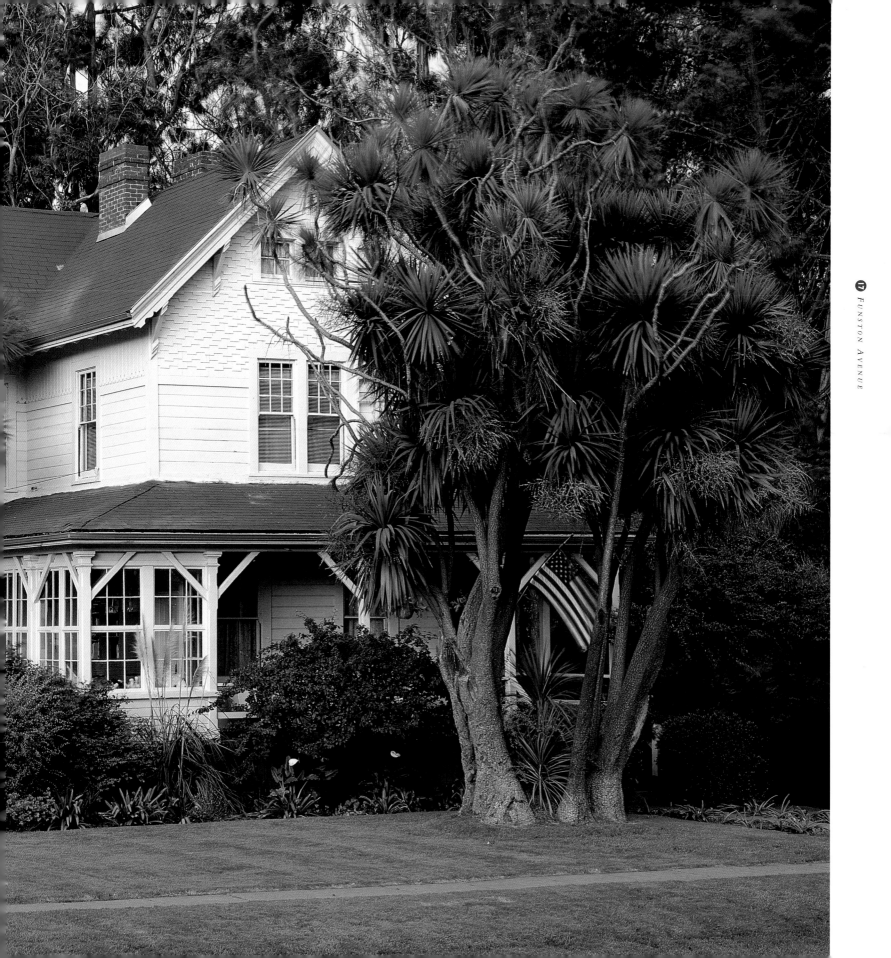

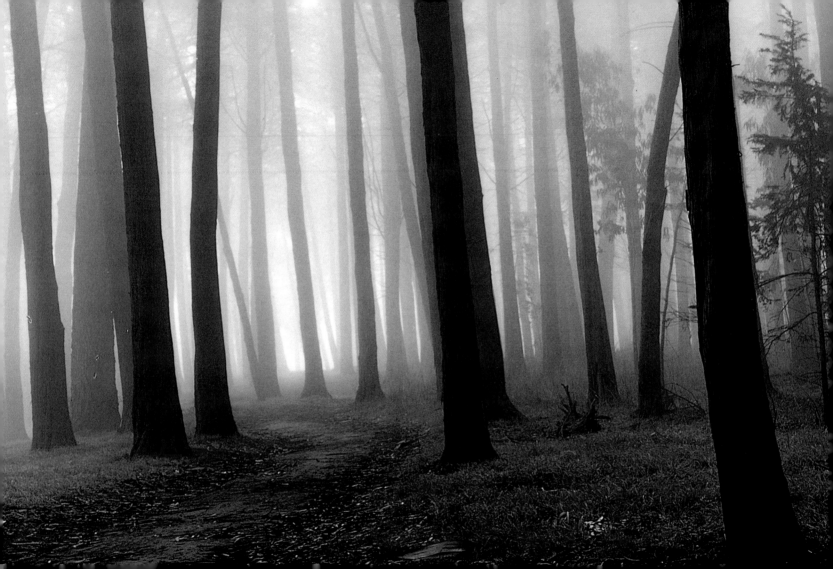

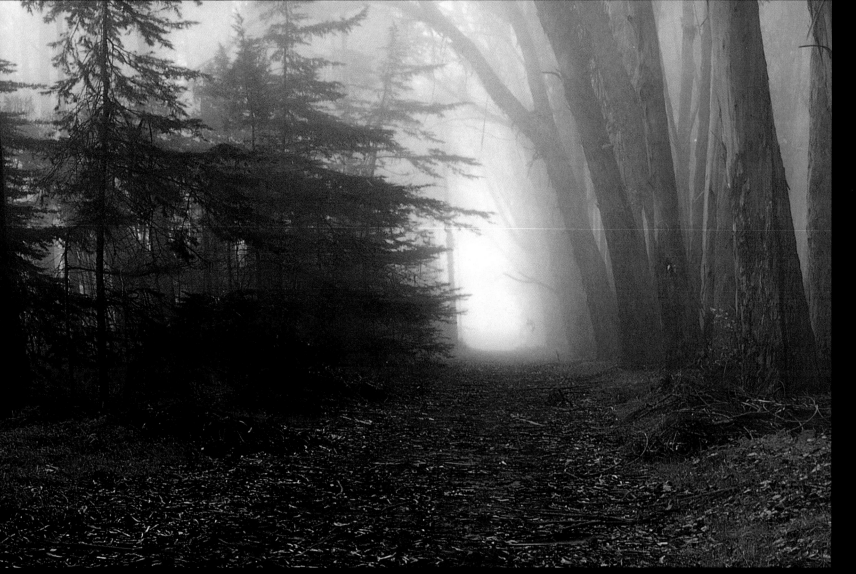

T he Presidio's forested setting
is largely due to a beautifica-
tion plan developed by division engi-
neer Major William Albert Jones in
1883. Before the planting, civilians
often secured permits to graze their

Built in 1932 as the U.S. Public Health Service Hospital (PHSH), this building was constructed to replace the former Marine Hospital, which had served merchant mariners since 1875. The hospital was initially sited near Mountain Lake to secure a freshwater source. The PHSH was closed in 1981.

Right: The spot where Spanish Captain Juan Bautista de Anza III camped with his initial scouting party in 1776, Mountain Lake today fronts a popular neighborhood park. Ducks and other waterfowl make their home among the tules. Part of Mountain Lake's shoreline was buried in the 1930s to provide a freeway approach for the Golden Gate Bridge.

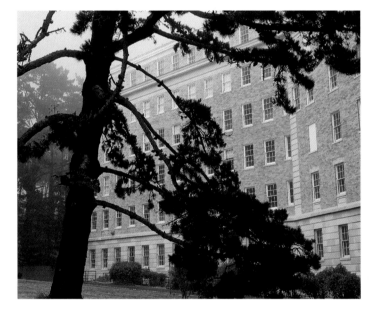

⑲ *U.S. PUBLIC HEALTH SERVICE HOSPITAL*

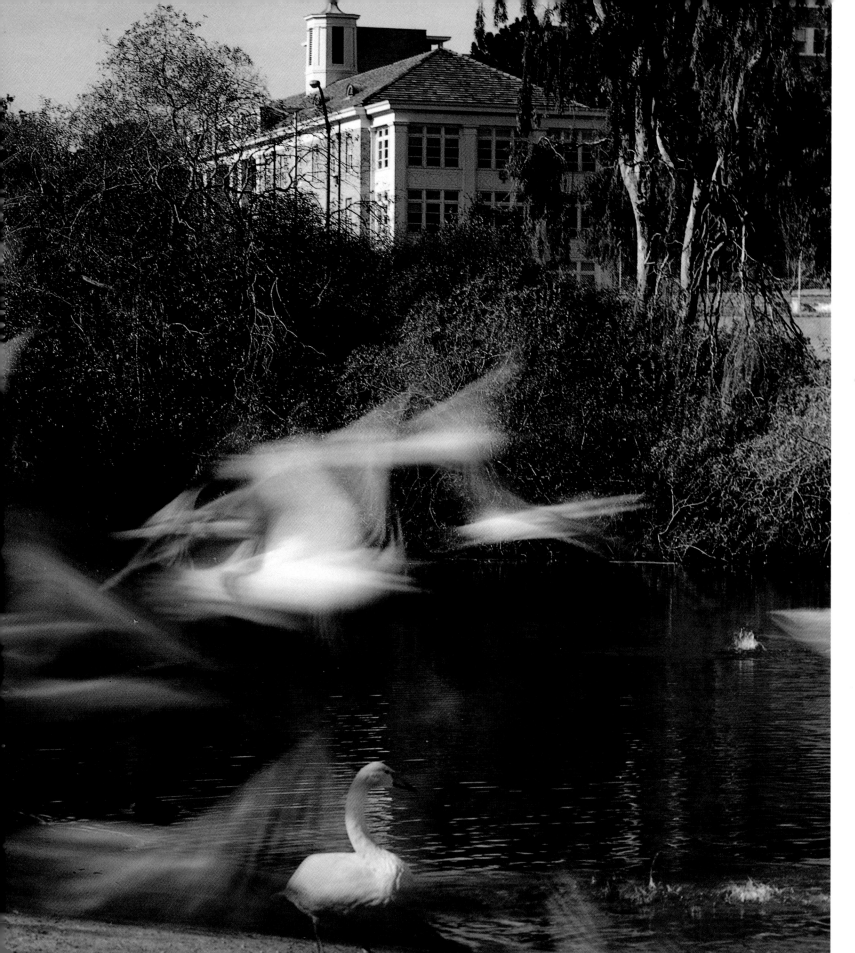

P lanting of the Presidio forest won the enthusiastic support of San Francisco citizens. On Arbor Day 1886, philanthropist Adolph Sutro donated 3,000 seedlings, and 4,000 women and children arrived at the Presidio to plant the trees in holes dug by soldiers.

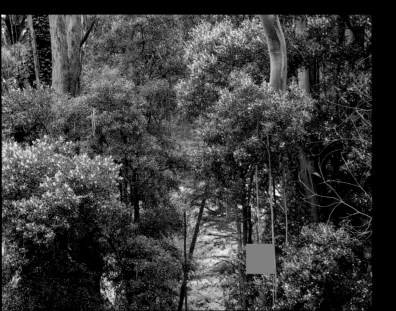

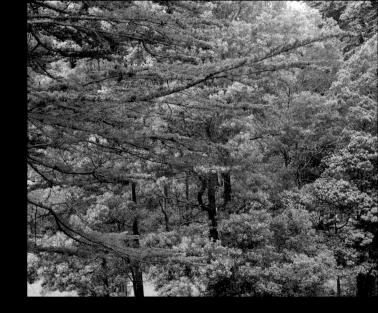

The California poppy, which
grows throughout the
Presidio, was one of the native
species first documented by natural-
ists on the Russian sailing vessel

Tucked along the southern border of the Presidio is the city-run Julius Kahn Playground, which has served the military community and families from neighboring districts since 1923.

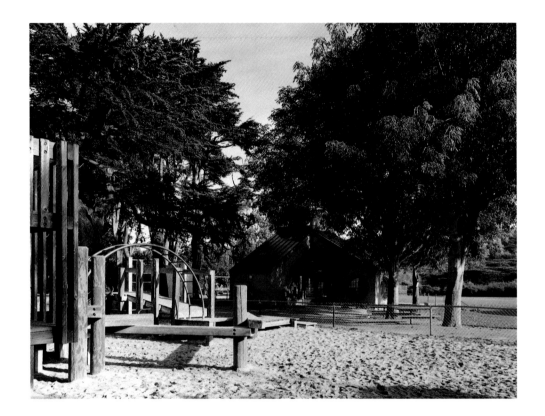

21 *JULIUS KAHN PLAYGROUND*

Acacias and other ornamental trees line the trails that wind through Tennessee Hollow. Centuries ago this valley held special significance to the local Ohlone Indians because of *El Polin,* "the pollen," a freshwater spring that legend associated with fertility. Today this watershed attracts a large number of hummingbirds and supports a varied plant community that includes native willows.

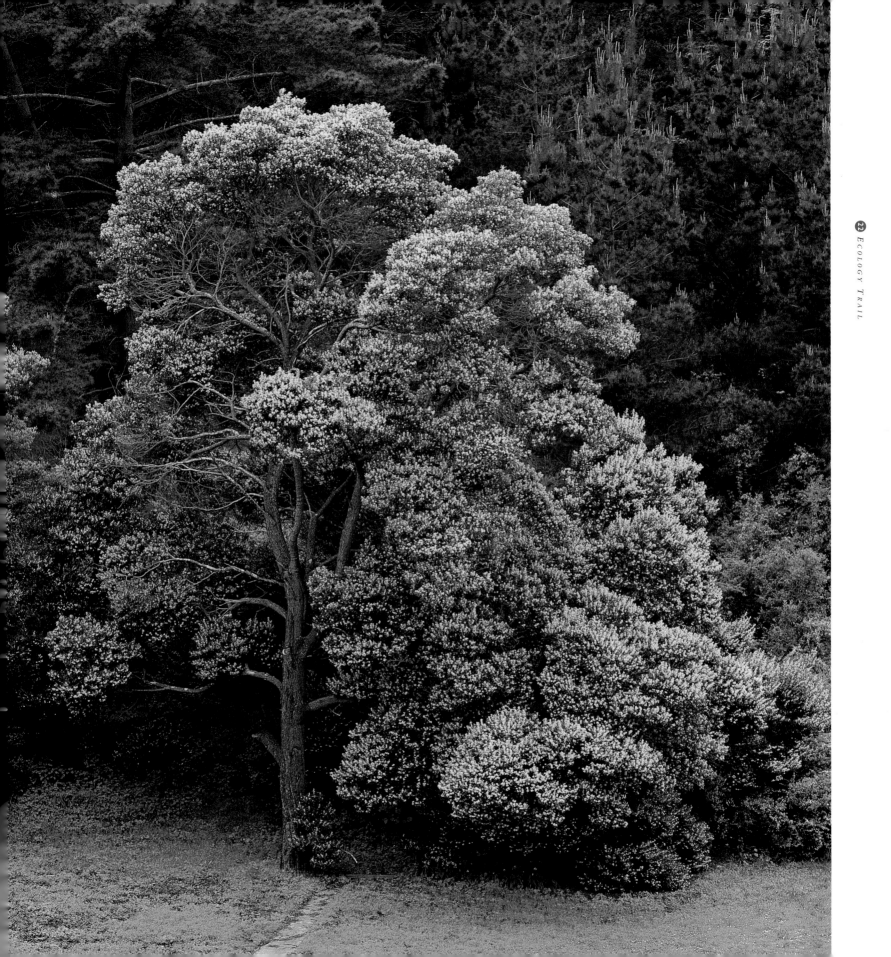

Beautifully preserved Georgian Revival-style homes on quiet tree-lined streets create a pleasant small-town neighborhood atmosphere in Tennesee Hollow.

An ecology trail that crosses the Presidio takes hikers through forests, around serpentine grassland meadows, and across an historic foot bridge located on Lovers' Lane, a favorite trysting spot in the late 19th century.

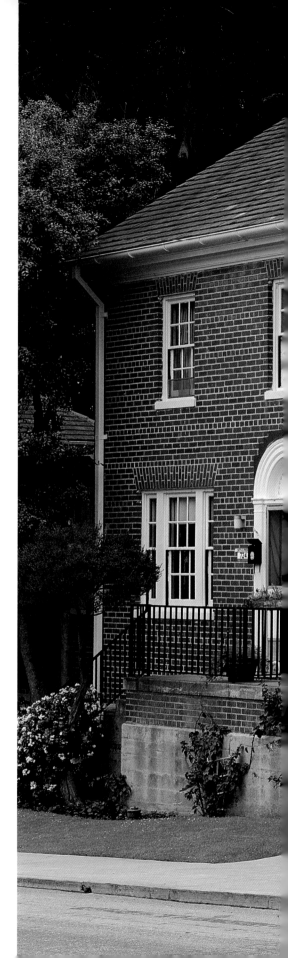

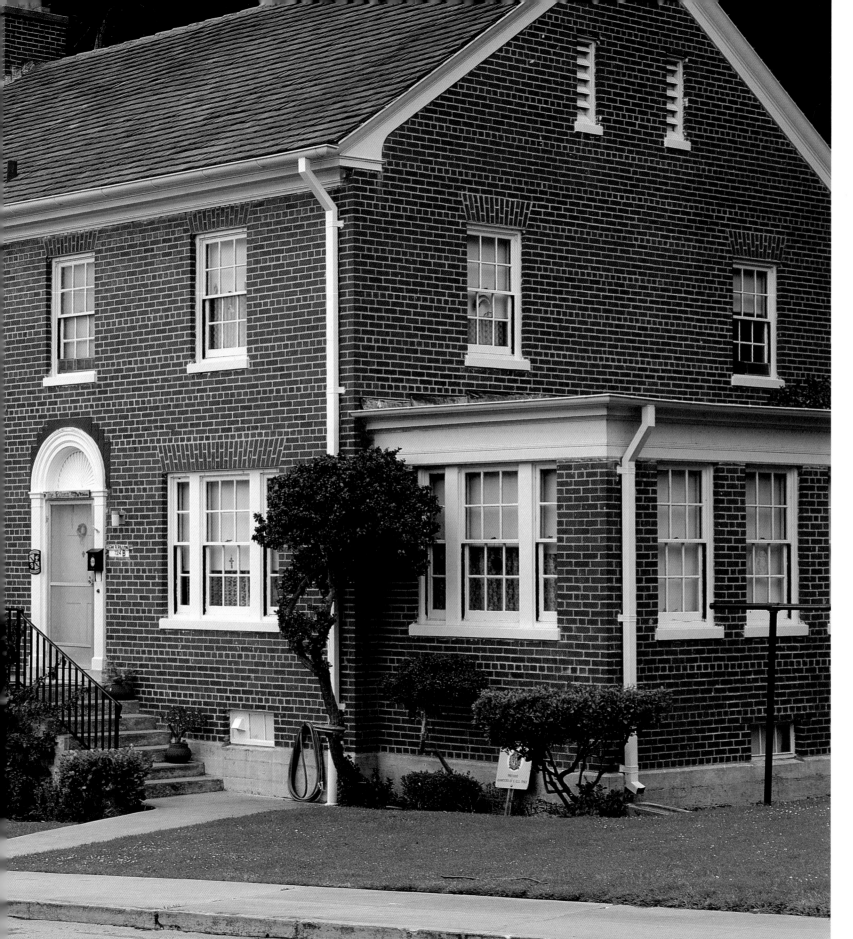

THE PRESIDIO

EAST GATE

Selected as the site of the original Spanish garrison because of its wind-sheltered location and commanding view of the bay, the eastern section, which houses the Main Post and Letterman Hospital complex, has been the heart of the Presidio since 1776. **T**he evolutionary development of the Presidio is most clearly evident on the Main Post, which has long been the scene of daily army activity. Constructed over successive generations, the buildings that span out concentrically from the post's central parade ground represent a cross section of historical architectural styles. From Civil War-era wooden barracks to pre-Spanish-American War Victorian officers' quarters to World War I Mission Revival homes, the Presidio contains one of the finest collections of U.S. military architecture in the nation.

With roads that weave through groves of trees and past scenic vista points and historic military structures, the Presidio is a fascinating place for cyclists and hikers to explore. Most of the roads were laid out in the days of horse-drawn wagons, so the easy-to-moderate grades allow cyclists to enjoy a leisurely ride. *Right:* WPA funds allowed the construction of what was then called the "War Department Theatre," built in the Mediterranean Revival style. The theatre opened in 1939 with "I'm From Missouri."

29 *MAIN POST*

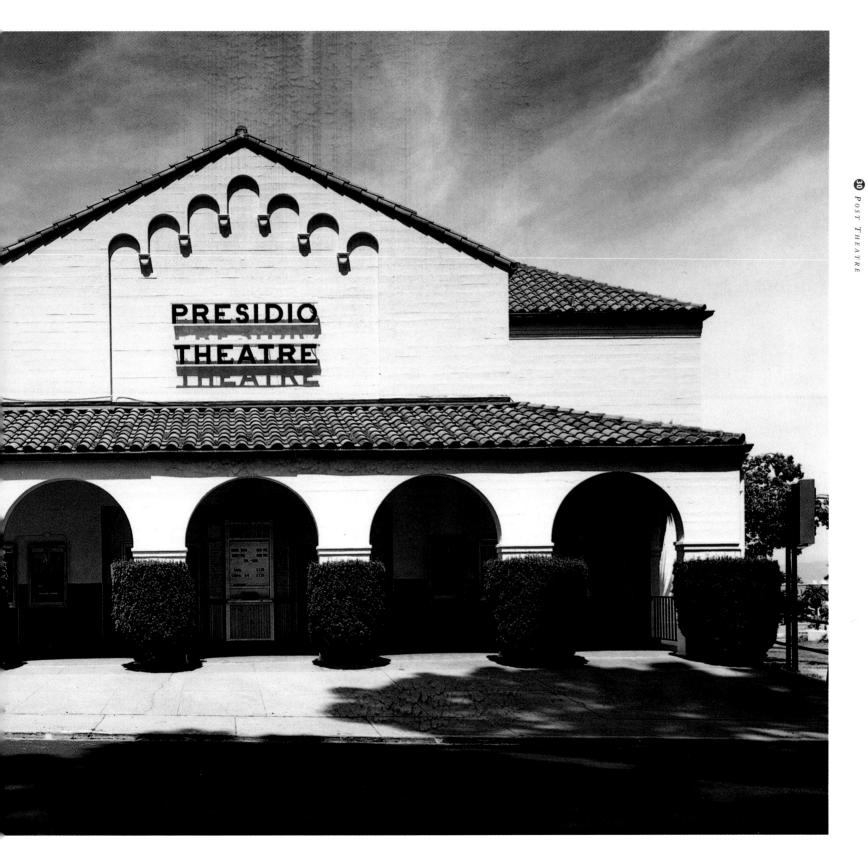

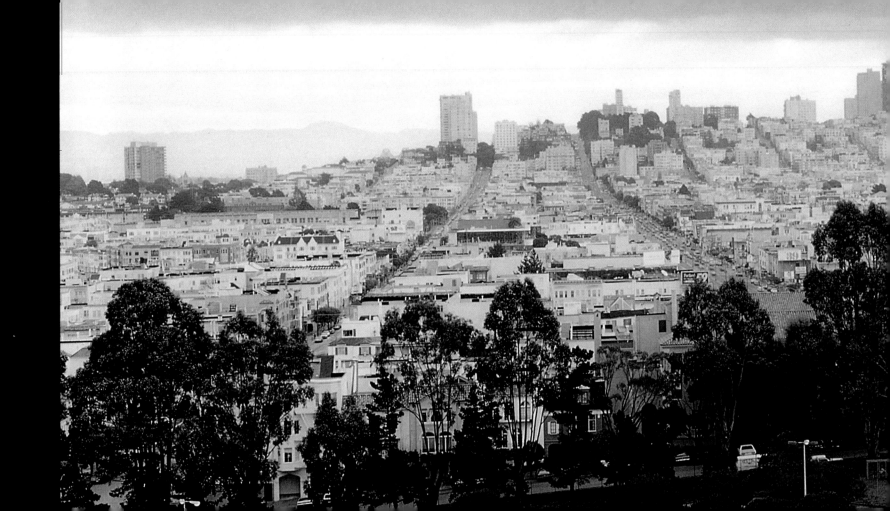

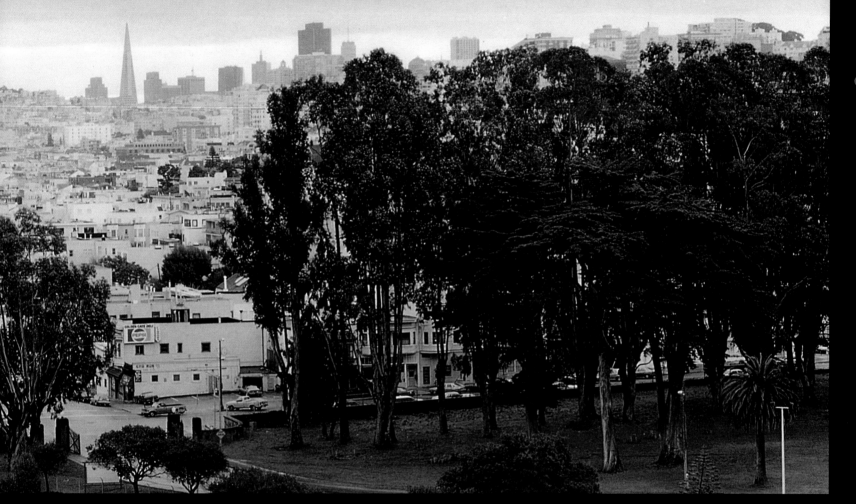

"In order to make the contrast
from the city seem as great as
possible...I have surrounded all the
entrances with dense masses of
wood," wrote Major Jones in his
landscape plan. Today a grove of
trees along the Lombard entrance
marks the Presidio's eastern bound-
aries, with the city skyline beyond.

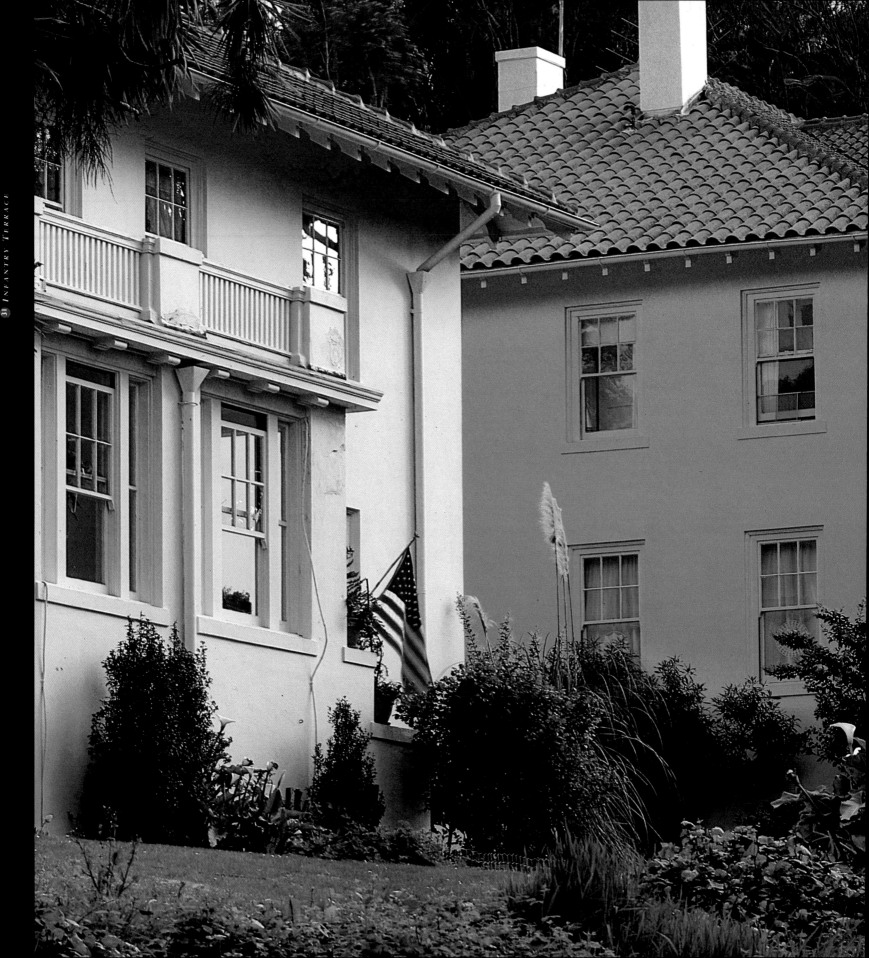

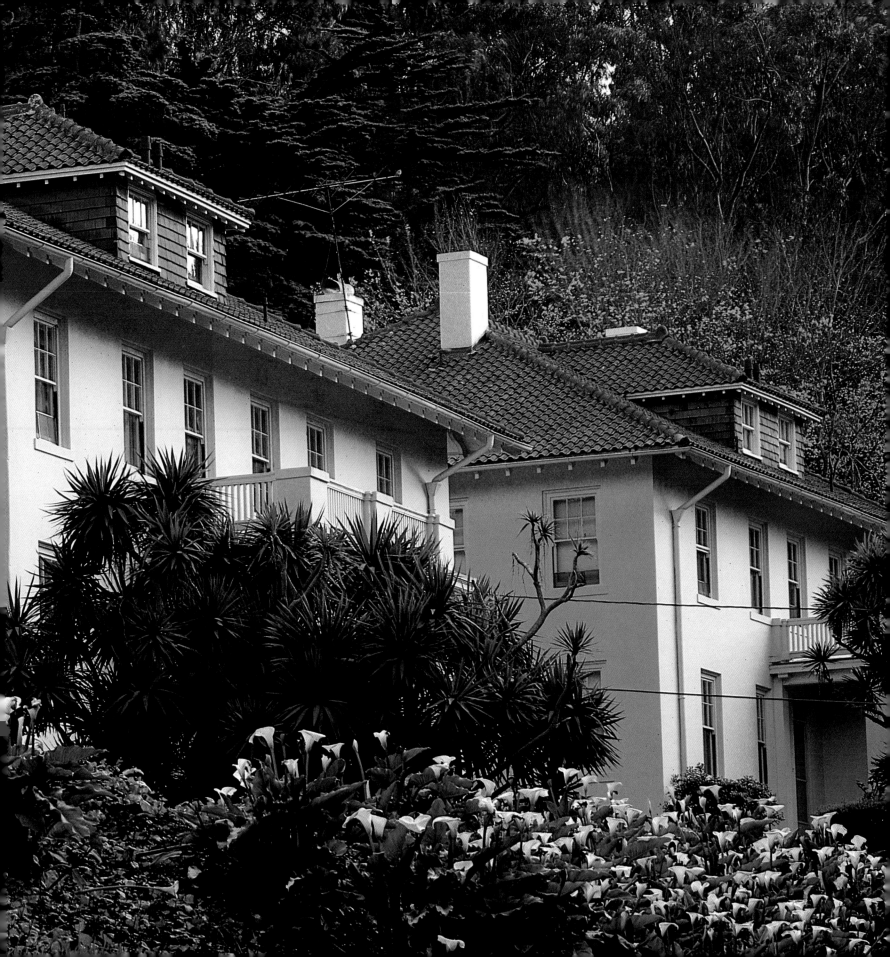

In 1895, the army constructed a row of Colonial Revival-style enlisted men's quarters, which became the first permanent barracks on the base. Some of these barracks were converted into a hospital during the Spanish-American War, and later the entire complex served as headquarters for the 30th U.S. Infantry, which was stationed at the Presidio for more than forty years.
Right: A view from one of the homes on Infantry Terrace.

32 *MONTGOMERY STREET BARRACKS*

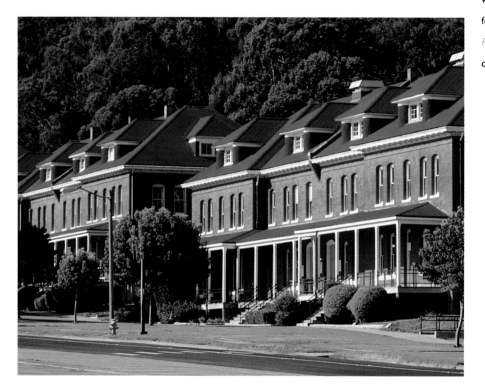

Previous:

Built a few years after the great earthquake of 1906, Infantry Terrace houses were made of reinforced concrete covered with stucco because concrete had survived the tremor better than brick construction.

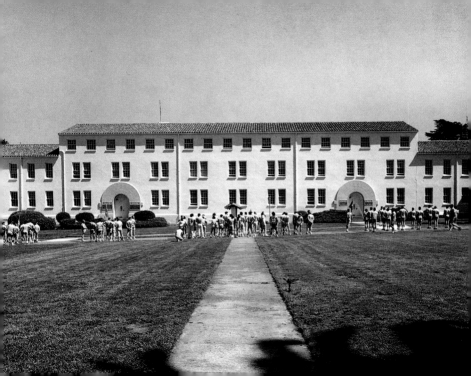

D isplayed outside the Presidio
Museum is a bronze cannon,
cast in France in 1754. Used by the
Spanish in Cuba, the cannon was cap-
tured by Americans during the
Spanish-American War in 1898. The
museum itself, located in the Civil
War-era hospital building, features
exhibits on the Presidio's history and

Built in 1885, this structure was originally the sutler's store and home of its civilian operator. It was acquired by the army and converted into an enlisted men's barracks in 1897.

Flowers line the walkway to Letterman Hospital, which treated battle casualties up through the Vietnam conflict. More recently, Letterman provided health care for military members, their families, and retirees and maintained a medical research institute.

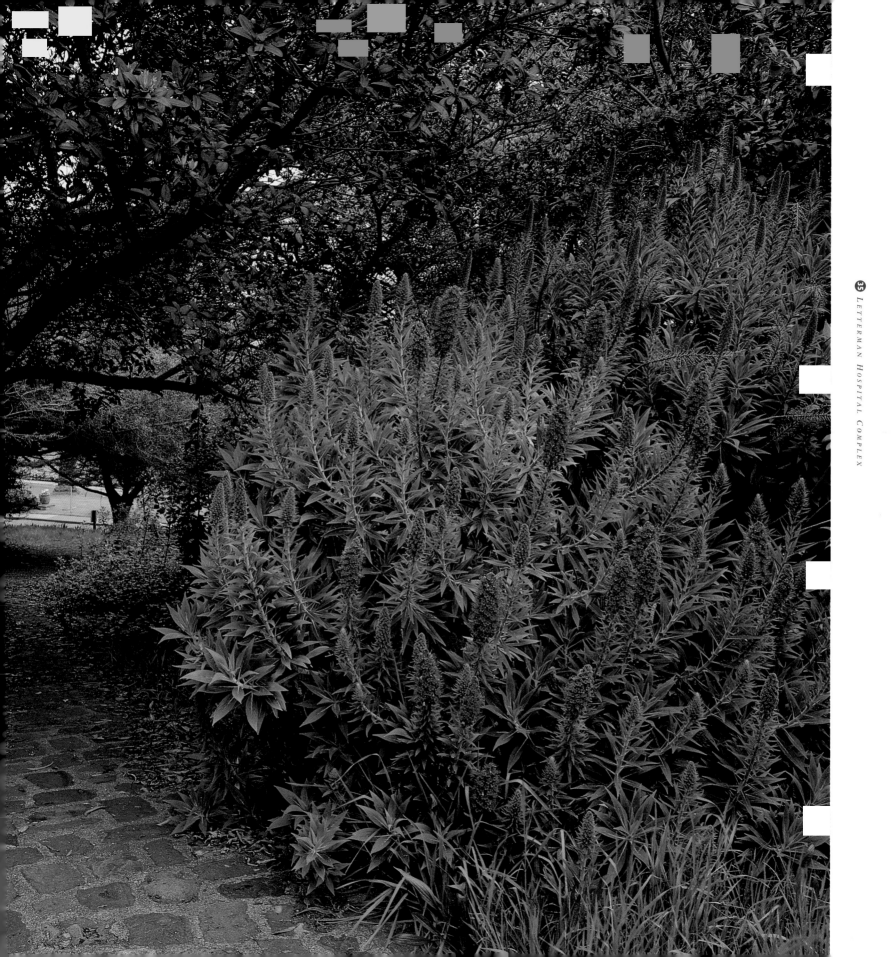

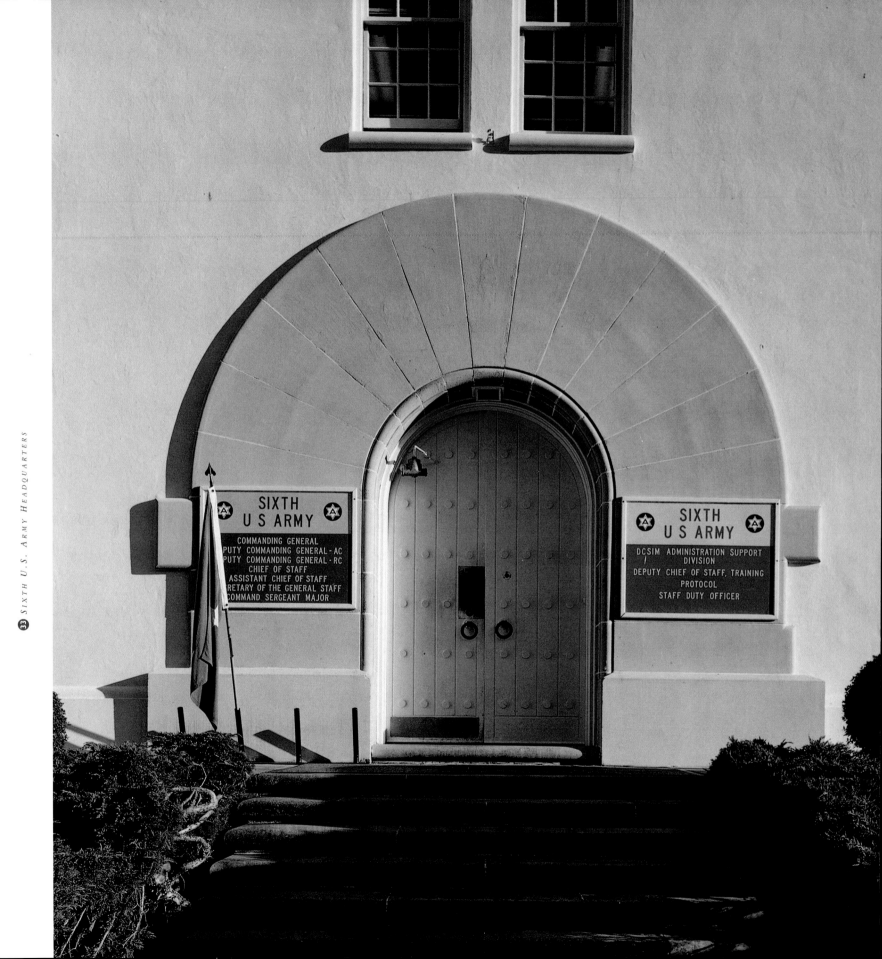

This building was originally
constructed to serve as
barracks for enlisted men, but as
World War II approached, it
was converted into offices for the
newly activated Fourth U.S. Army.
More recently it has served as the
Sixth U.S. Army headquarters.

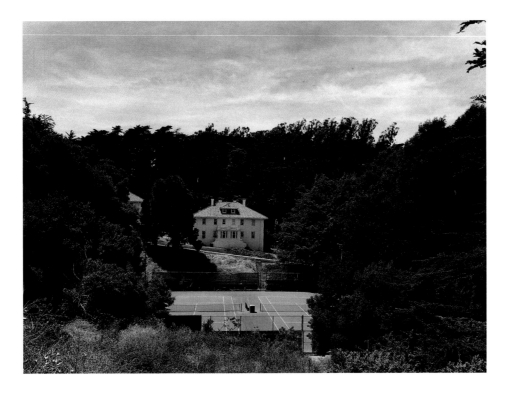

Officers' homes on Infantry
Terrace were frequently the
scene of elegant receptions for
dignitaries traveling to the Pacific.
Following the Spanish-American
War in the Philippines, the Presidio
acquired greater importance in
terms of the nation's defense.

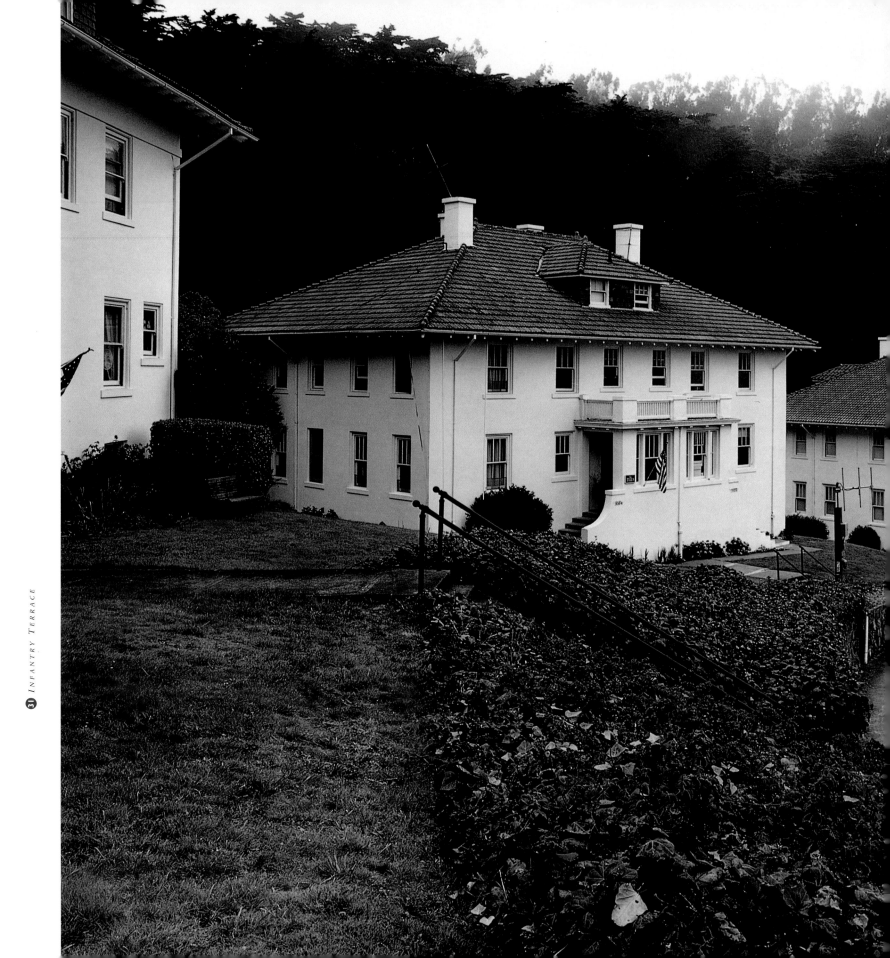

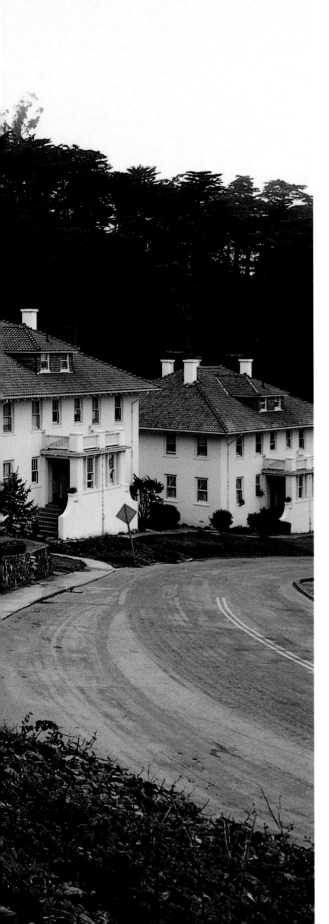

Following a plan laid out by
Major William Harts, Infantry
Terrace homes were sited on con-
tour lines rather than in traditional
military-style straight rows to create
a graceful, residential atmosphere.
Below: The Presidio has long been
the scene of colorful military
ceremonies.

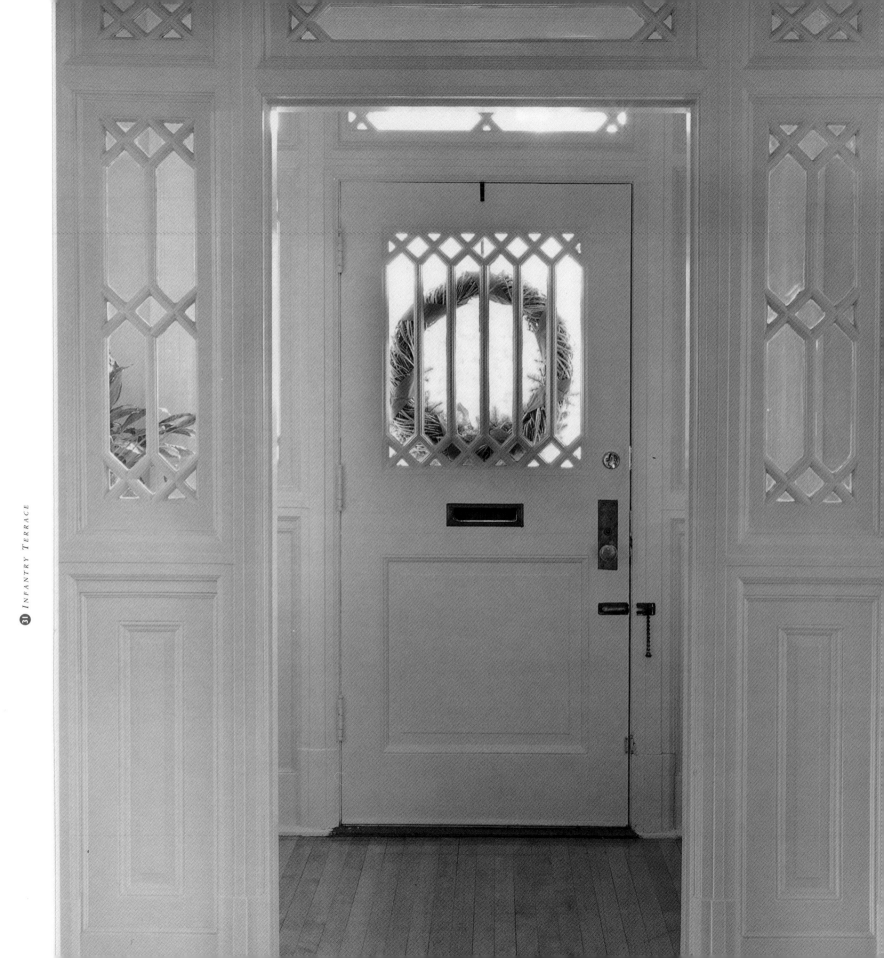

Beveled glass and other elegant interior details in Infantry Terrace homes reflect the Victorian style popular at the turn of the century. Built about the time that electricity was introduced on the Main Post, Infantry Terrace houses incorporated electrical wiring and fixtures.

31 *INFANTRY TERRACE*

Following:

The parade ground, along with the flag pole, is the center of every military post. The Presidio's parade ground has been the site of much pomp and circumstance as well as the scene of daily drills.

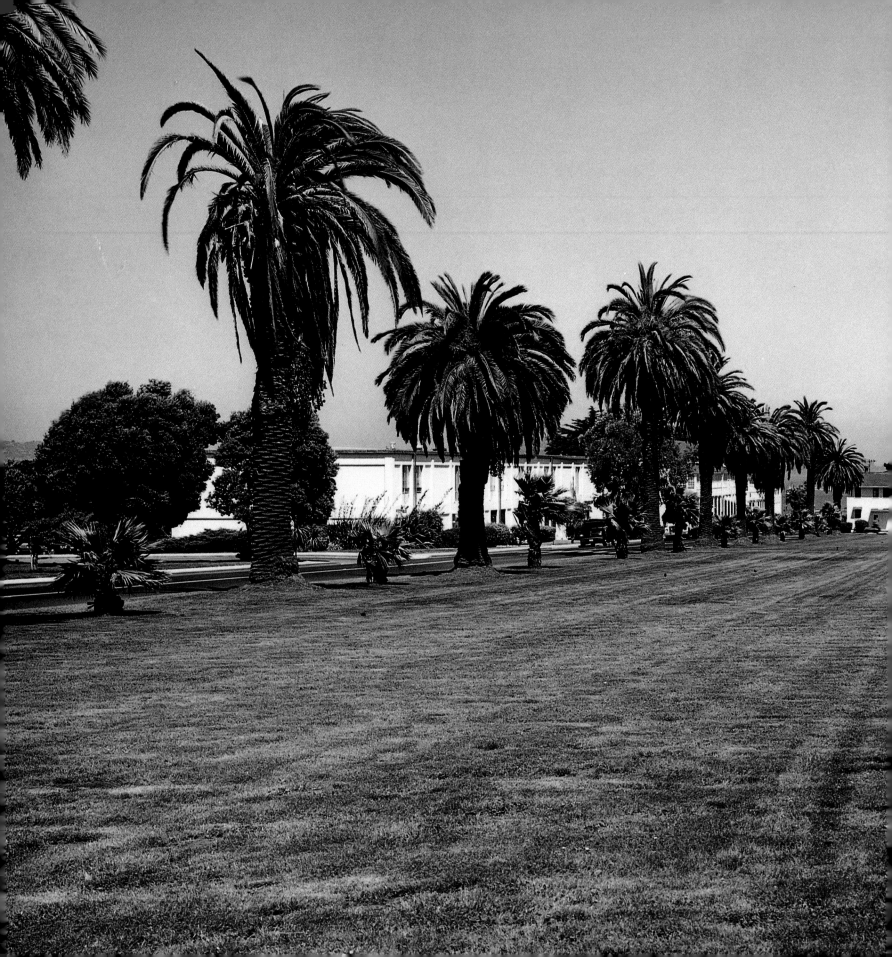

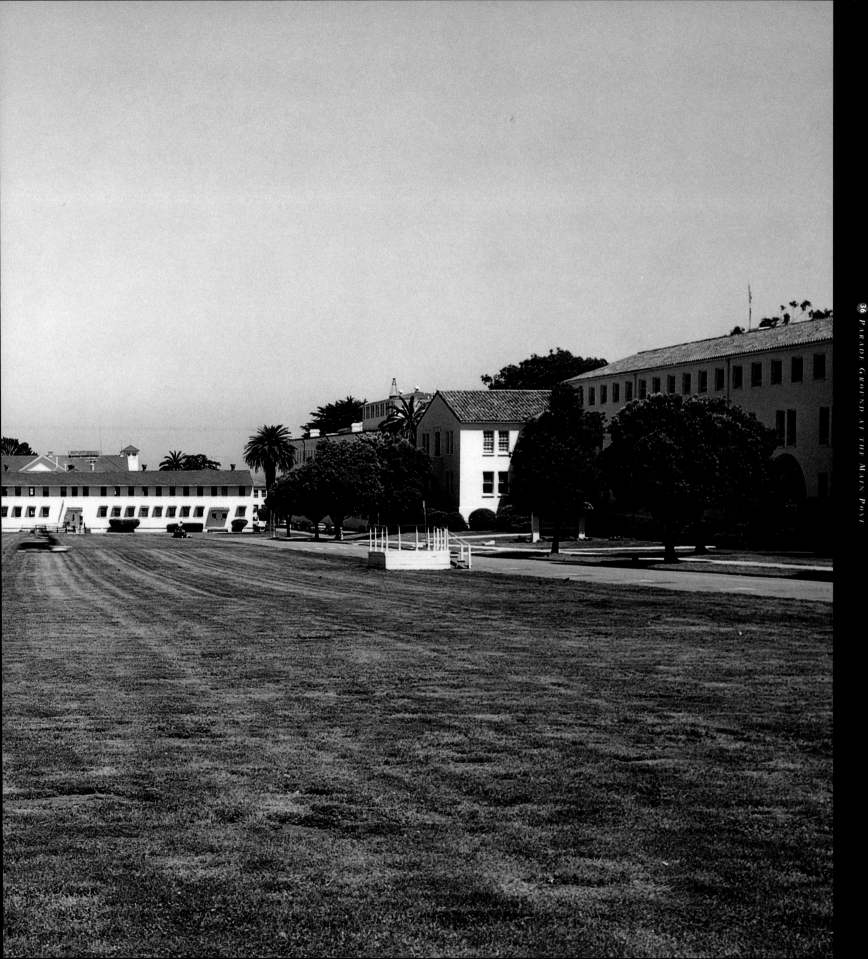

In 1884 the *Alta California* praised: "All about the residence quarters shade trees and cultivated flowers contribute to make the place beautiful. The business part [has] ornamental footwalks, marked by inviting resting places amid flowers and shrubs. The border lines are...long rows of half-buried cannon balls."

Right: This building was part of the original Letterman Hospital complex, established in 1899 to treat Spanish-American War soldiers returning from the Pacific with battle wounds and tropical diseases.

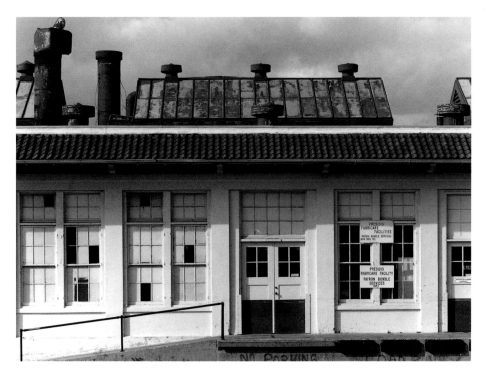

THE PRESIDIO

WEST GATE

The least-developed part of the Presidio, the western border overlooking the Pacific shelters some of San Francisco's last undisturbed native plant communities, including a number of threatened and endangered species. Live oak and willows line the banks of Lobos Creek. Serpentine grasslands provide a place for wildflowers to flourish, and the last remnant of the dune community that once covered almost half of San Francisco survives here. This rich biological diversity has been recognized by the United Nations, which included the Presidio within an International Biosphere Reserve, one of two hundred seventy in the world. Nearly hidden in this urban wilderness are the defensive batteries that were strategical-ly sited along the bluff between 1853 and 1960. Today they stand as silent reminders of the nation's military vigilance.

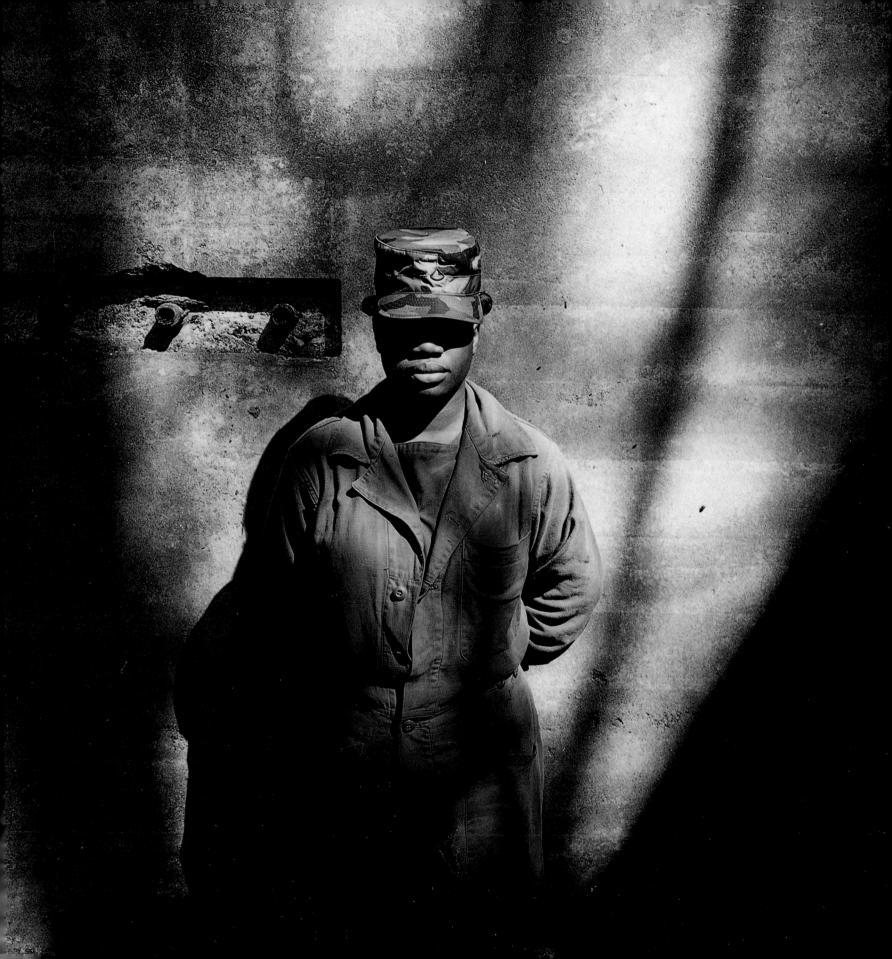

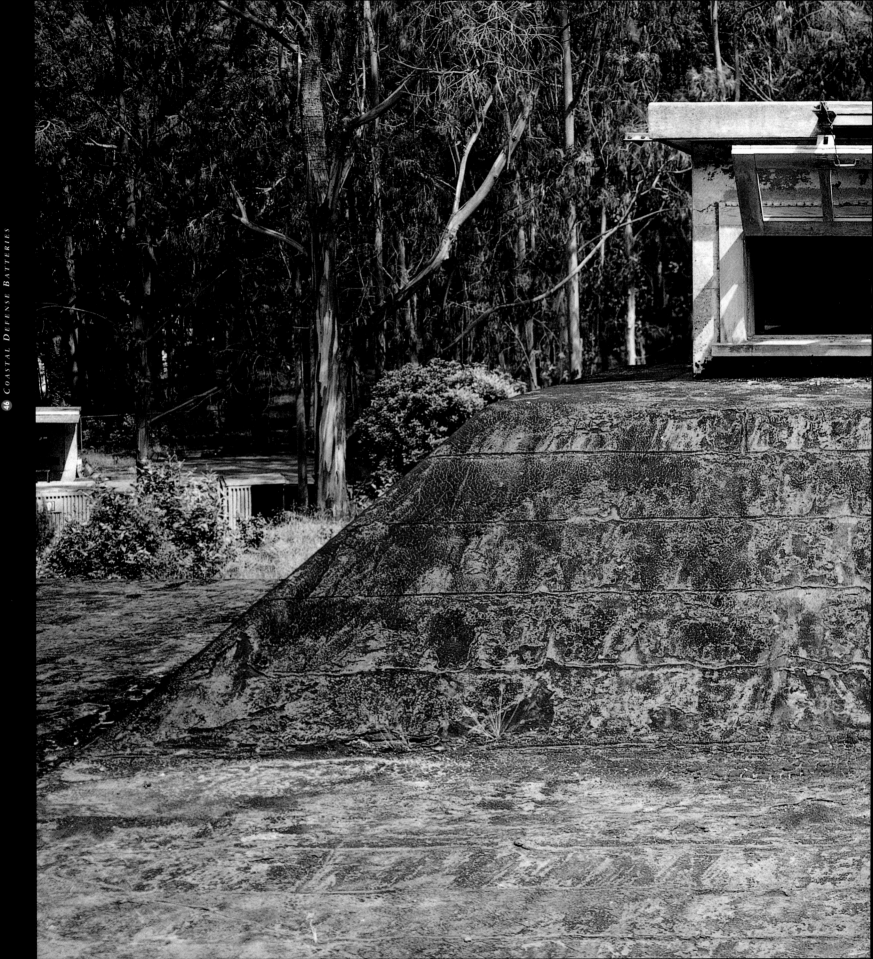

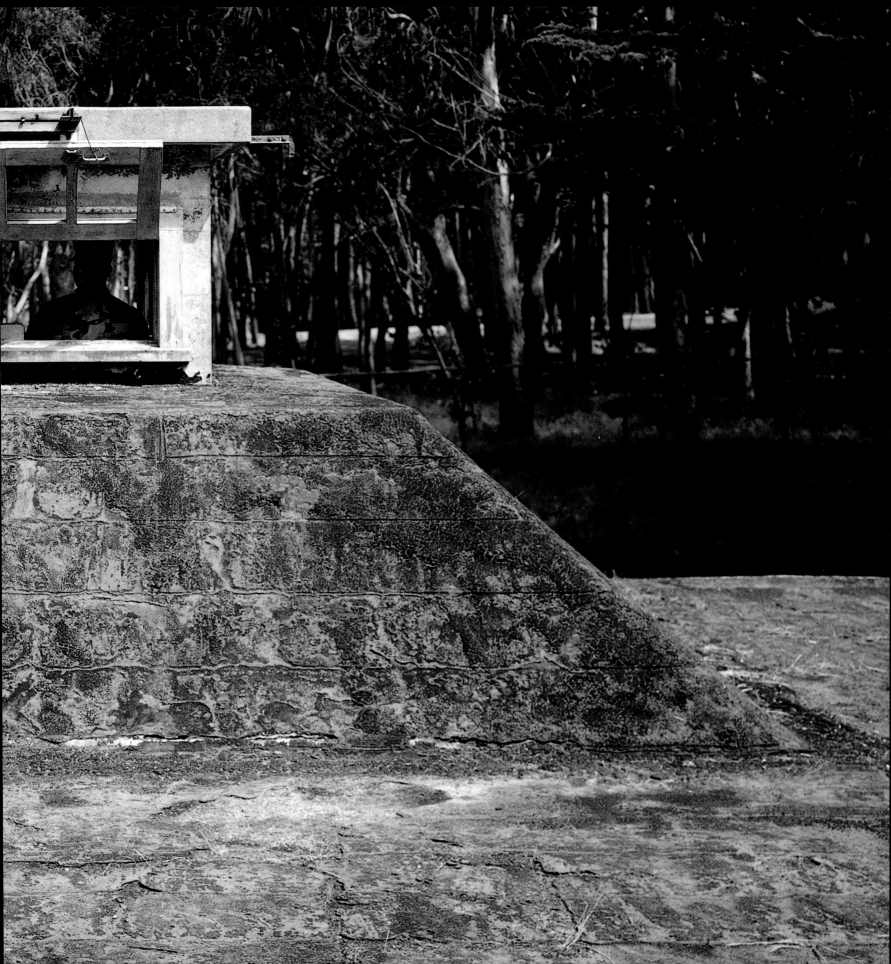

Built in 1895 to mount improved rifled artillery, batteries with concrete magazines and twenty-foot-thick earthen parapets held key coastal positions by the Golden Gate. Initially one of the two U.S. coastal batteries to mount experimental dynamite guns, Battery Dynamite was recalled to service during World War II as the San Francisco Harbor Defense Command Post. In 1944, a two-story structure was built atop the parapet to house operating personnel.

46 *COASTAL DEFENSE BATTERIES*

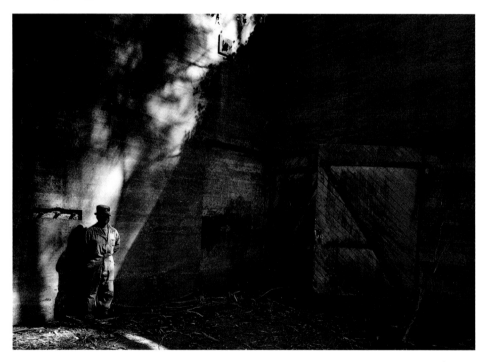

The morning and evening mist that blows in on stiff ocean breezes continually changes the mood of the Presidio forest and contributes to its beauty and mystery.

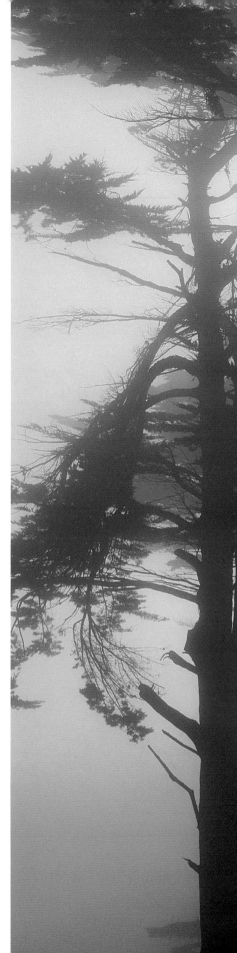

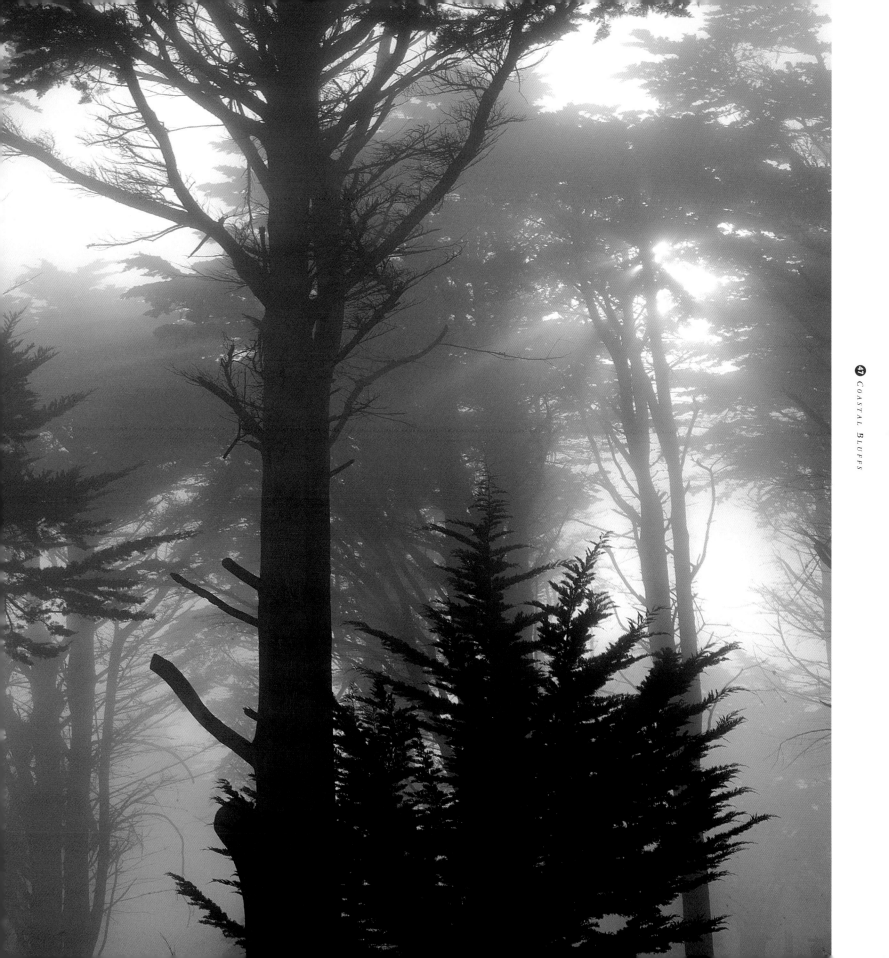

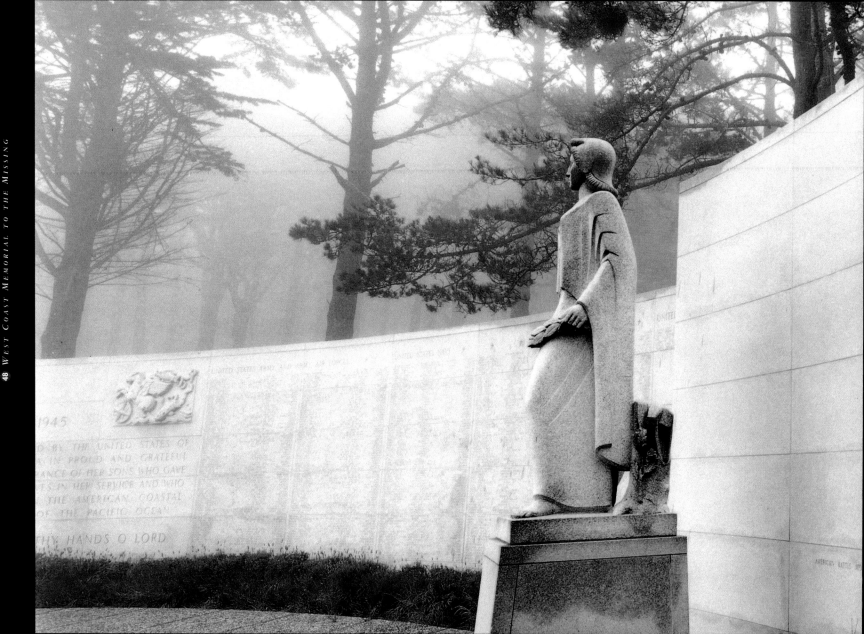

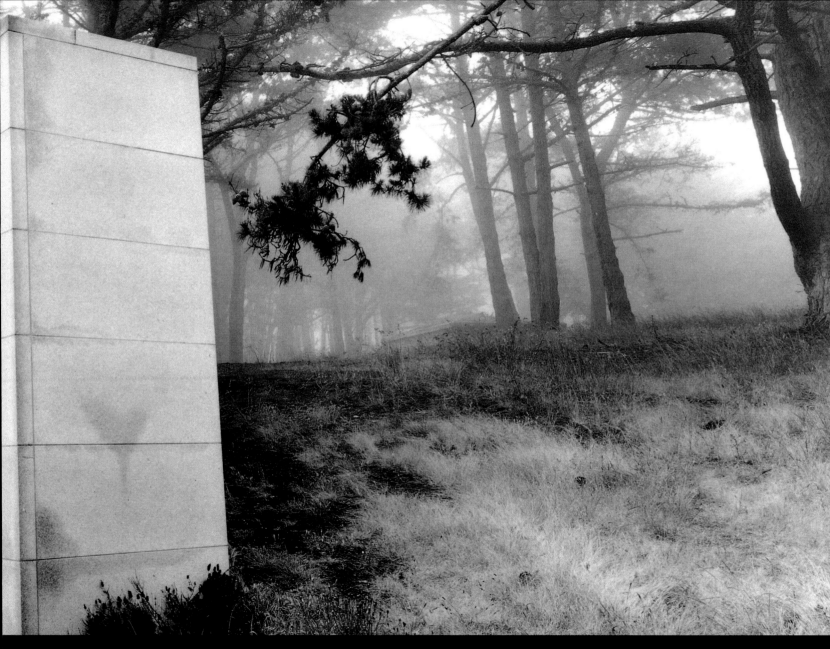

S et in a grove of Monterey pine
and cypress overlooking the

The last free-flowing stream in San Francisco, Lobos Creek has provided drinking water to the Presidio for more than a century. The creek and the seep that feeds it support riparian woodland, mixed evergreen, and northern coastal scrub communities that include rare plant species and provide important wildlife habitat.

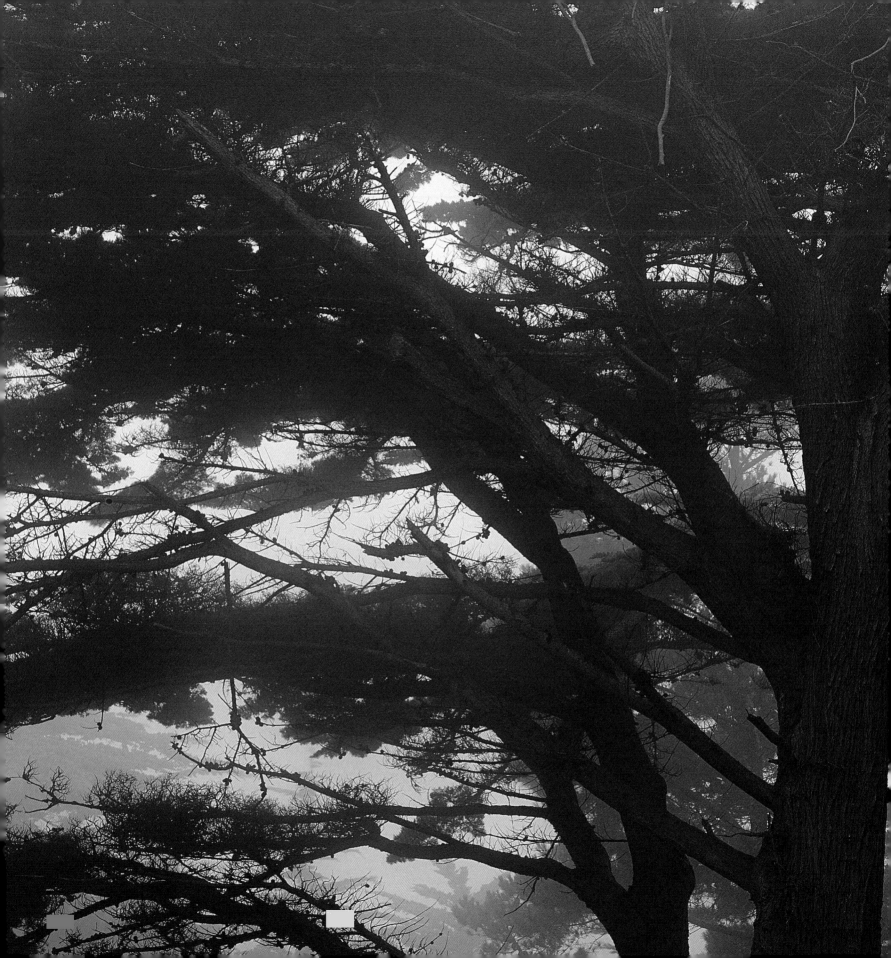

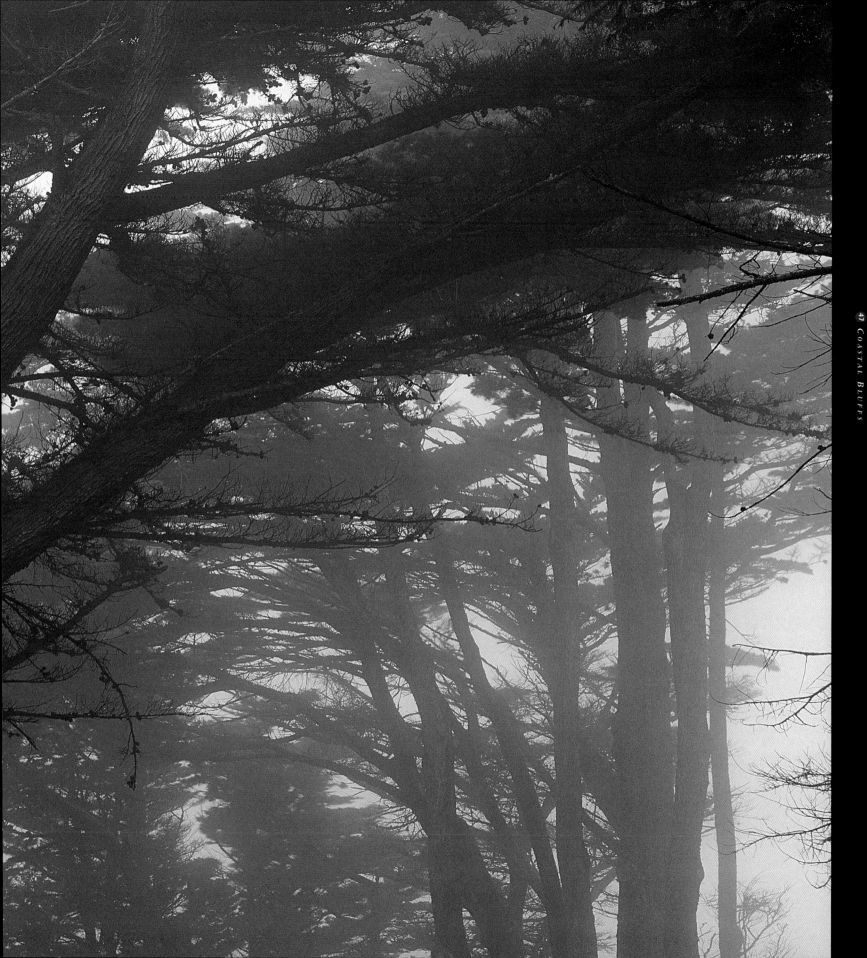

Previous:

"The desirability, from every point of view, of covering these bleak hillsides with a forest grove is so evident that it is considered unnecessary to enter into discussion," concluded General Funston in a 1905 report that urged other army posts in the Bay Area to follow suit.

Left: Installed around 1895, Battery Godfrey, mounted with three twelve-inch rifles, was the first modern coastal fortification to be completed at the Presidio. Its guns guarded the harbor until 1943.

Right: The Baker Beach dunes support a widely diverse plant community, including a number of native species.

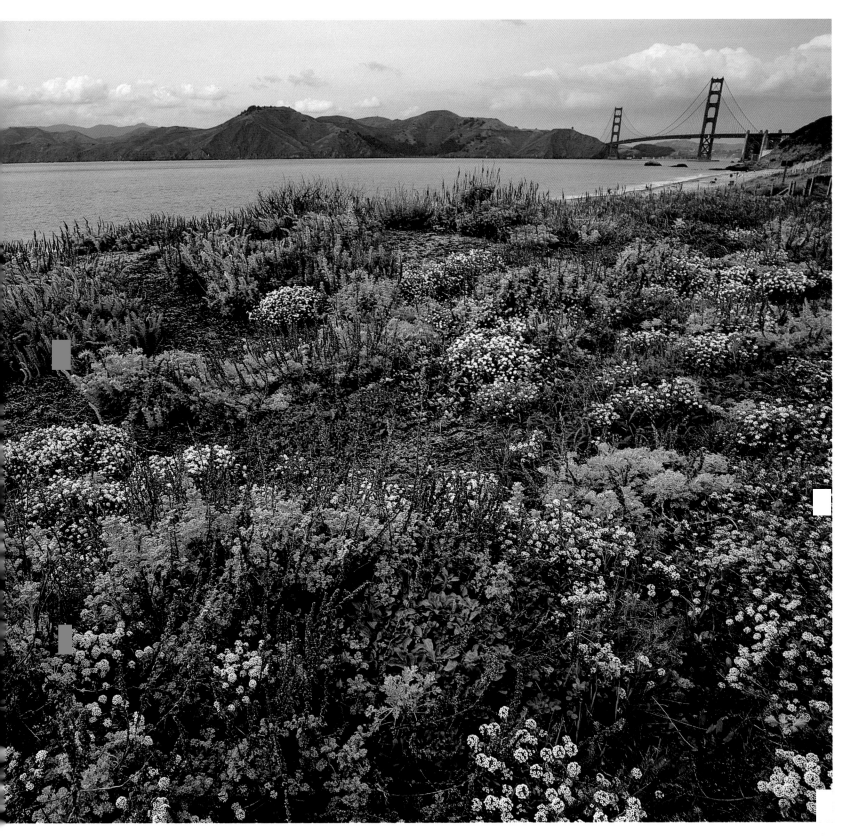

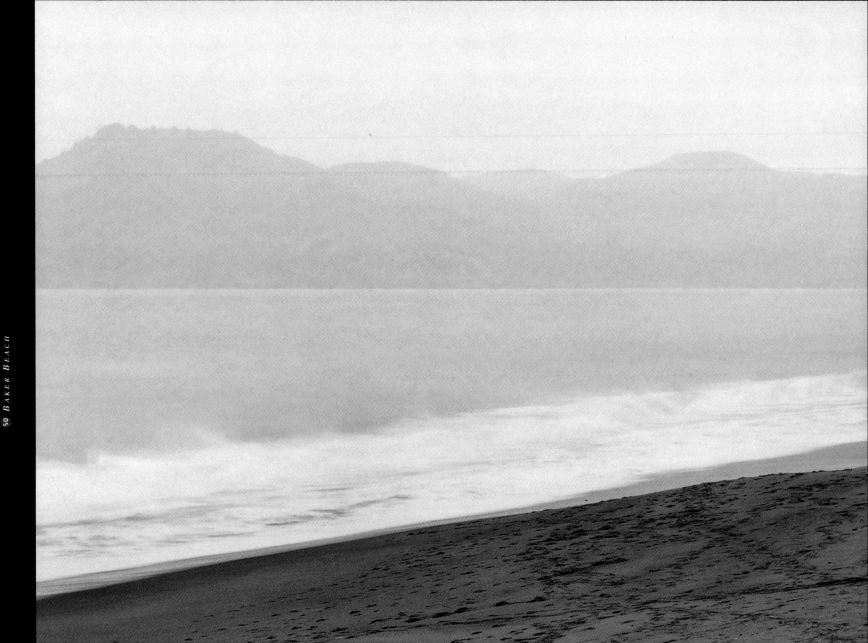

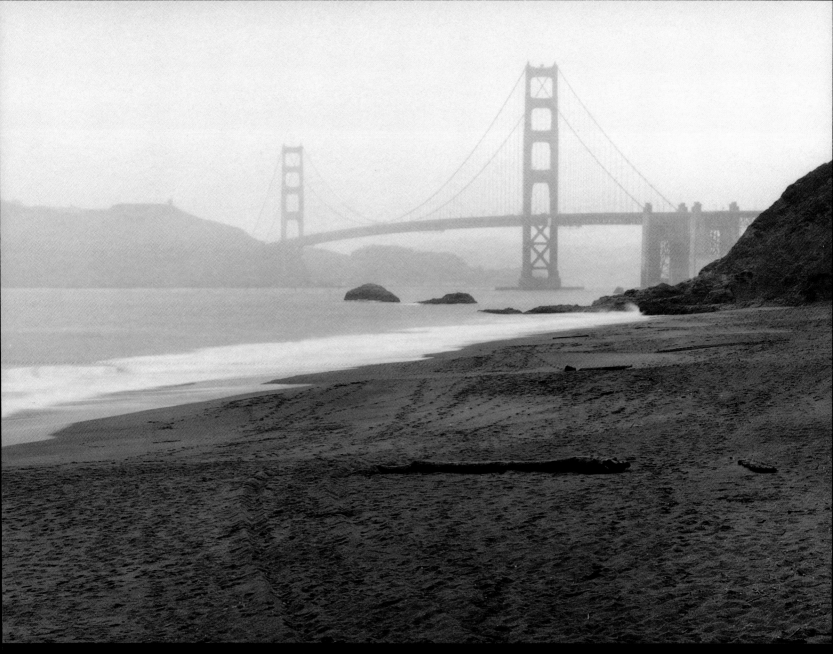

Baker Beach, a sandy shoreline favored by sunbathers and surf fishermen, offers an eye-level view of the Golden Gate Bridge and the Marin Headlands.

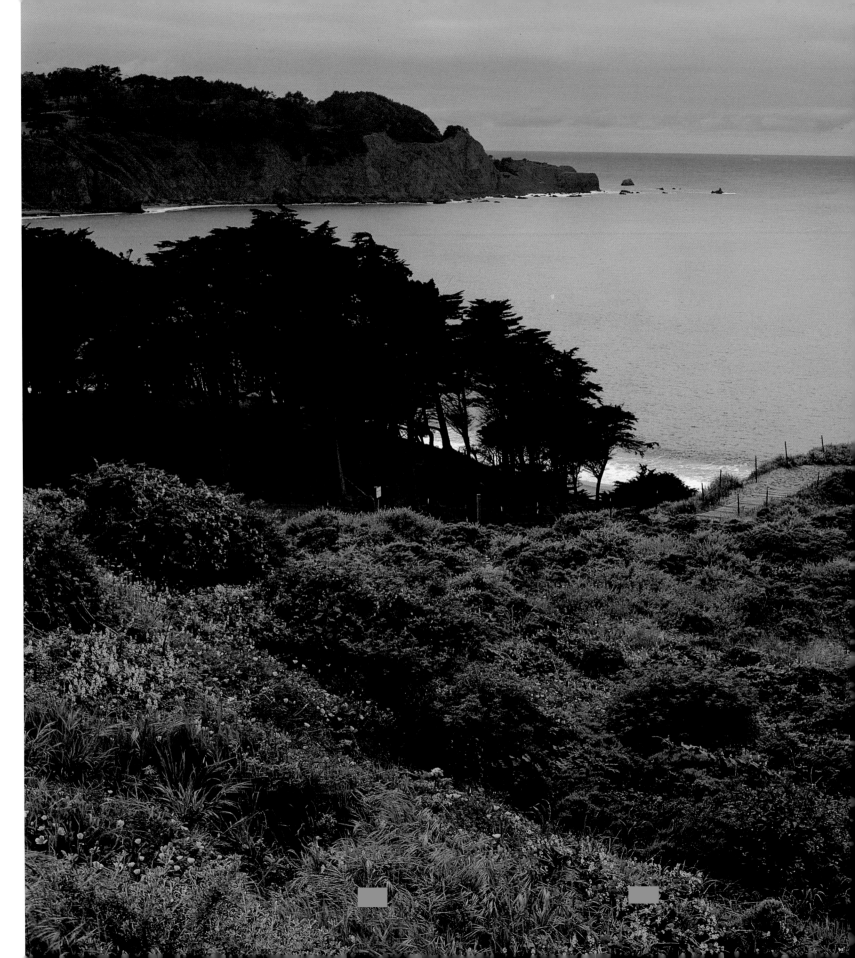

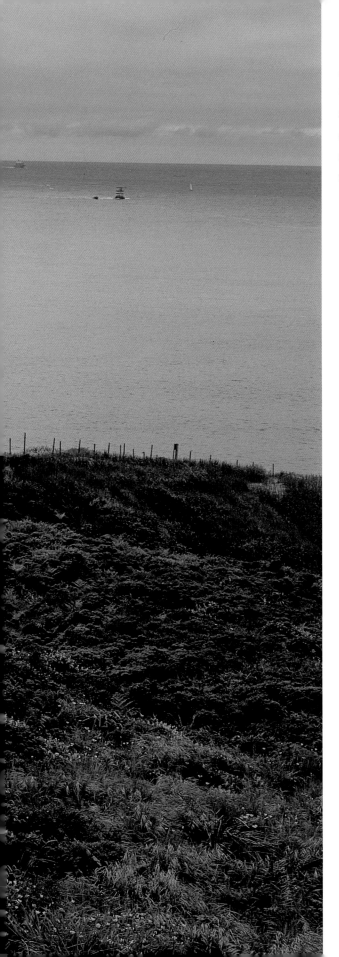

Some of the last undisturbed native plant communities in San Francisco are found along the coastal bluffs. The vegetation is the result of a mix of soil types, including rare serpentine rock.

47 *COASTAL BLUFFS*

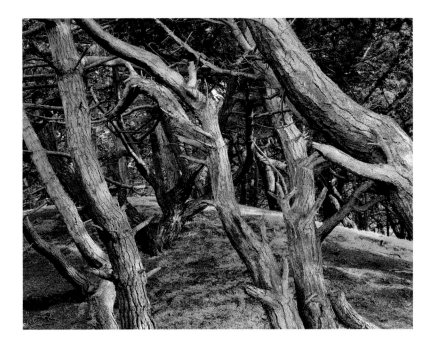

Forces of nature have sculpted the Presidio forest. Coastal winds and fog allow a diversity of plant life to thrive.

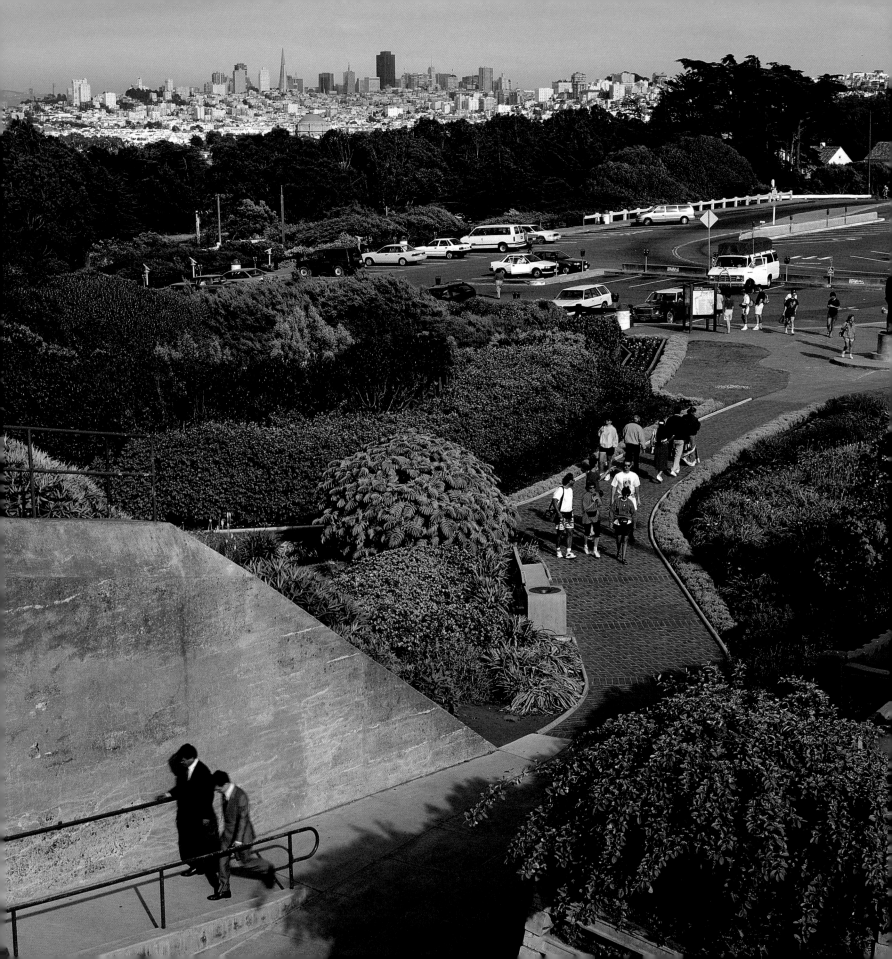

GATEWAY TO THE FUTURE

ROGER G. KENNEDY
DIRECTOR, NATIONAL PARK
SERVICE

Every generation or so, there appears an opportunity so wonderful, a time for action so precisely apparent, and a place so right, that even our contentious species cannot and will not lose the chance to achieve a grand result. So it is with creation of the national park and environmental study center at the Presidio. **T**he opportunity is the sudden availability of the most beautiful and historic large, open, urban space in the world not already set aside as a park. The time is now: national, state, and local authorities are in concert with the philanthropic and academic communities and citizens of the area. All desire the maintenance of open space and the use of the constructed environment to create, in place of a military base, a new and permanent installation

Following:

Before the establishment of the National Park Service in 1916, soldiers served as caretakers of many national parks. In 1899, the Presidio's Troop F, Sixth Cavalry, posed atop a gigantic fallen tree in Yosemite National Park.

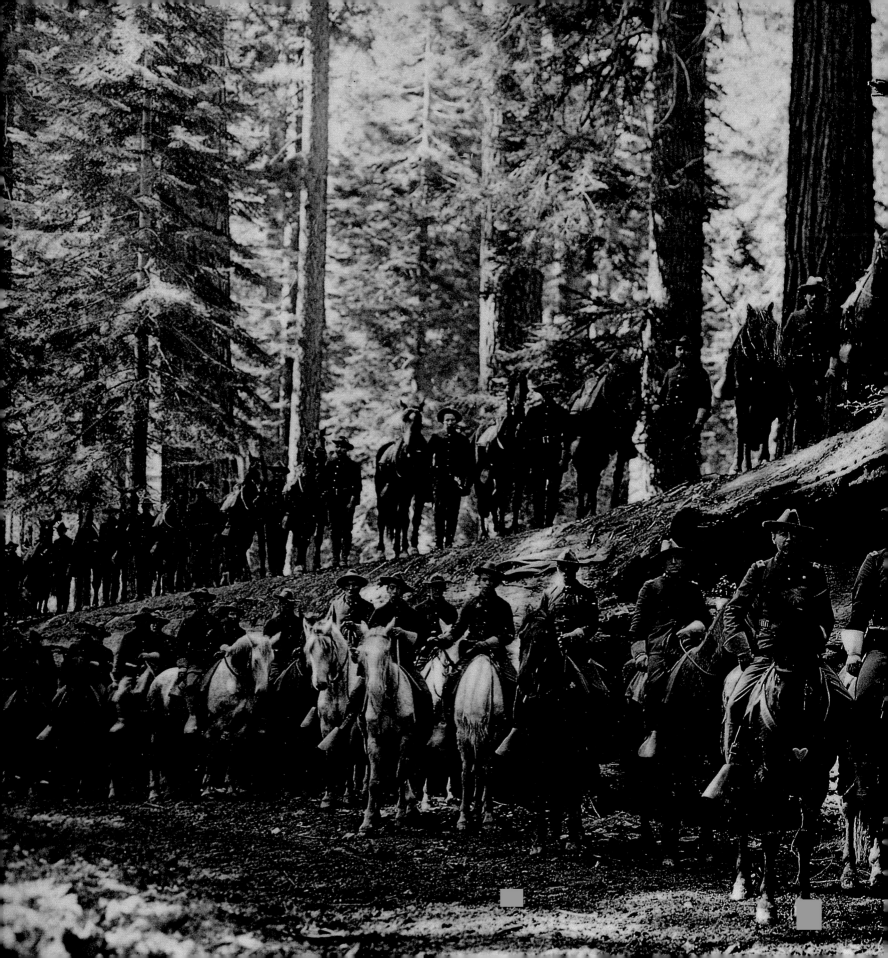

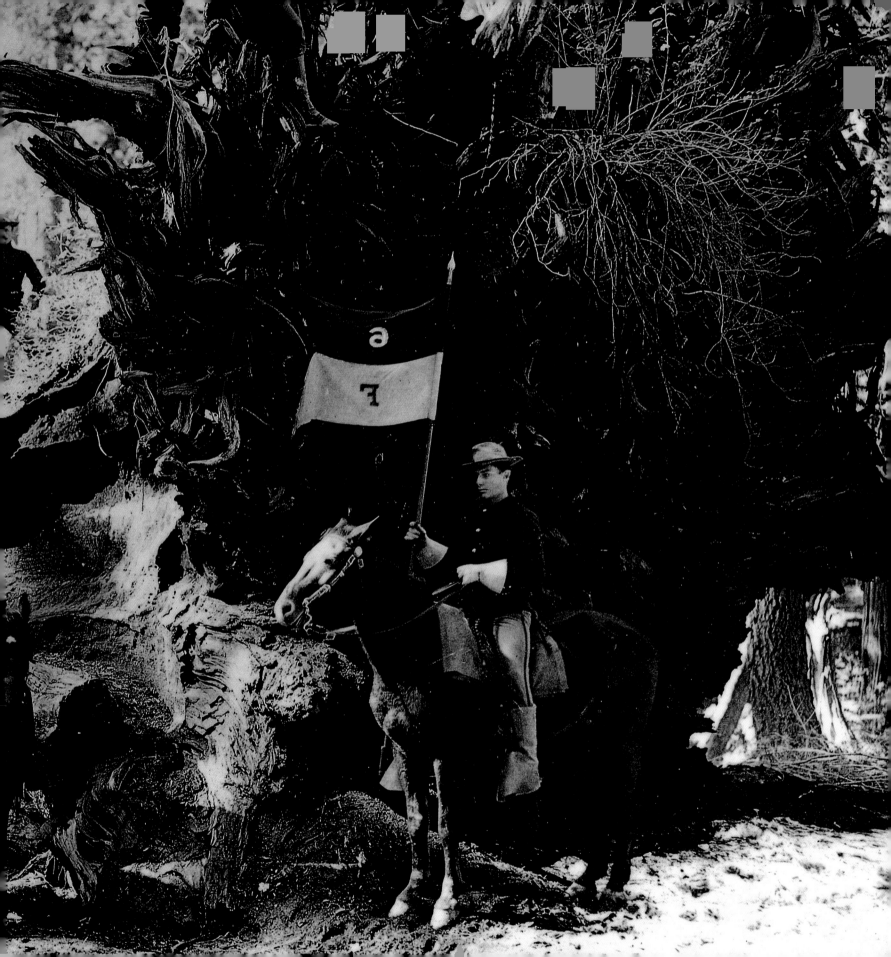

serving a peaceful world. **T**he Presidio has a history which implies its future. It lies upon a maritime frontier, and it lies at the verge of California, another kind of frontier. **P**eople were drawn to this region by the prospect of mineral wealth

extricated from the earth and by the less glittering but longer-lasting opportunities for agriculture in partnership with the earth. The Presidio is, therefore, an ideal setting in which to consider seriously how we must live in intersections and inter-relationships with both the natural and constructed environments. **T**he Presidio was

also the headquarters of a fortress. It invites conversion from a bristling citadel of military apprehensiveness to a confident and expansive center of growth and beneficial, peaceful change. The

The only known Raven's Manzanita plants in the world survive on Presidio grounds. The Presidio has been a haven to this endangered species as well as a wide variety of native plants, birds, reptiles, and mammals that once flourished in the Bay Area.

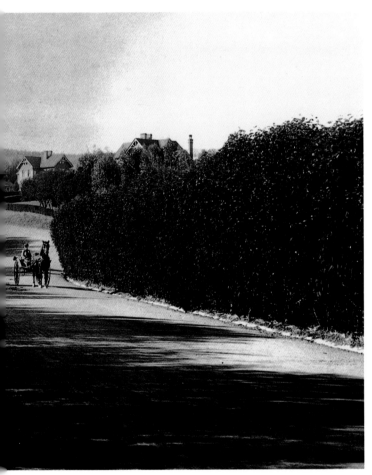

By 1900, Major Jones' tree-planting program had proved to be a success, and where there were once wind-blown grassy slopes, a forest of young trees appeared.

Presidio is a community within a park within a larger community. This wonderful concentricity invites us to create models of successful sustainability. We are reminded by such accidents of geography that each of us is placed in human life within the concentric circles of relationship to others and to the natural world. The Presidio can provide housing, office space, laboratories

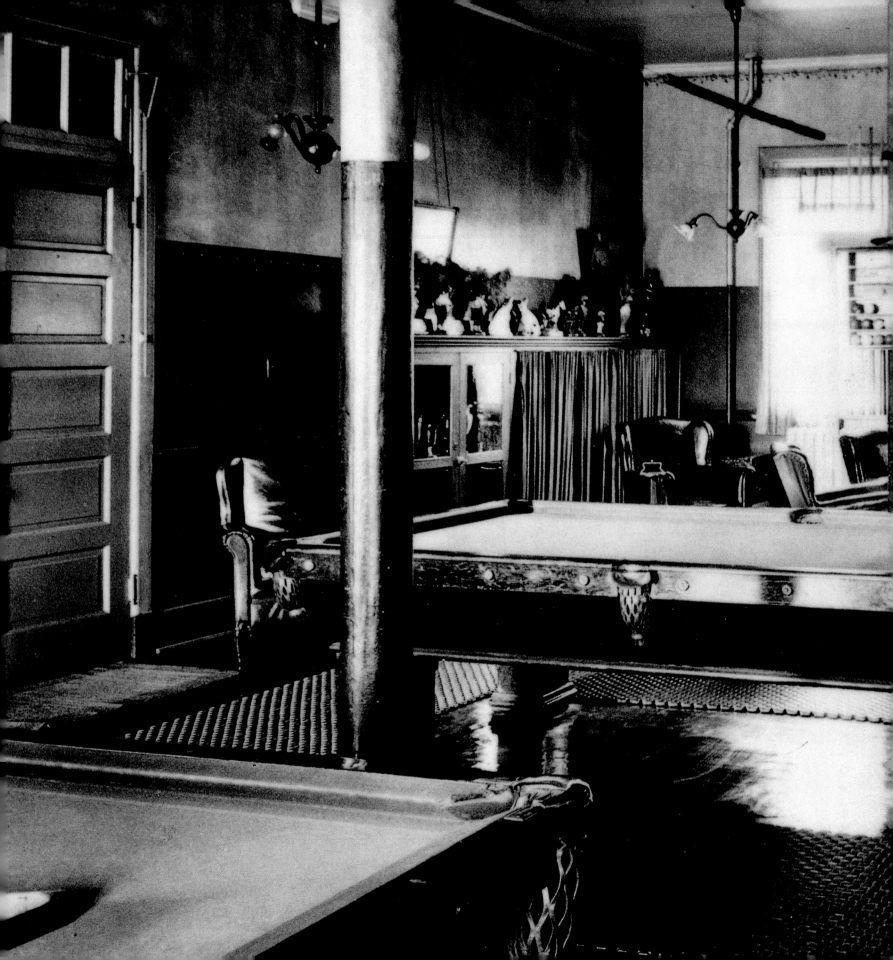

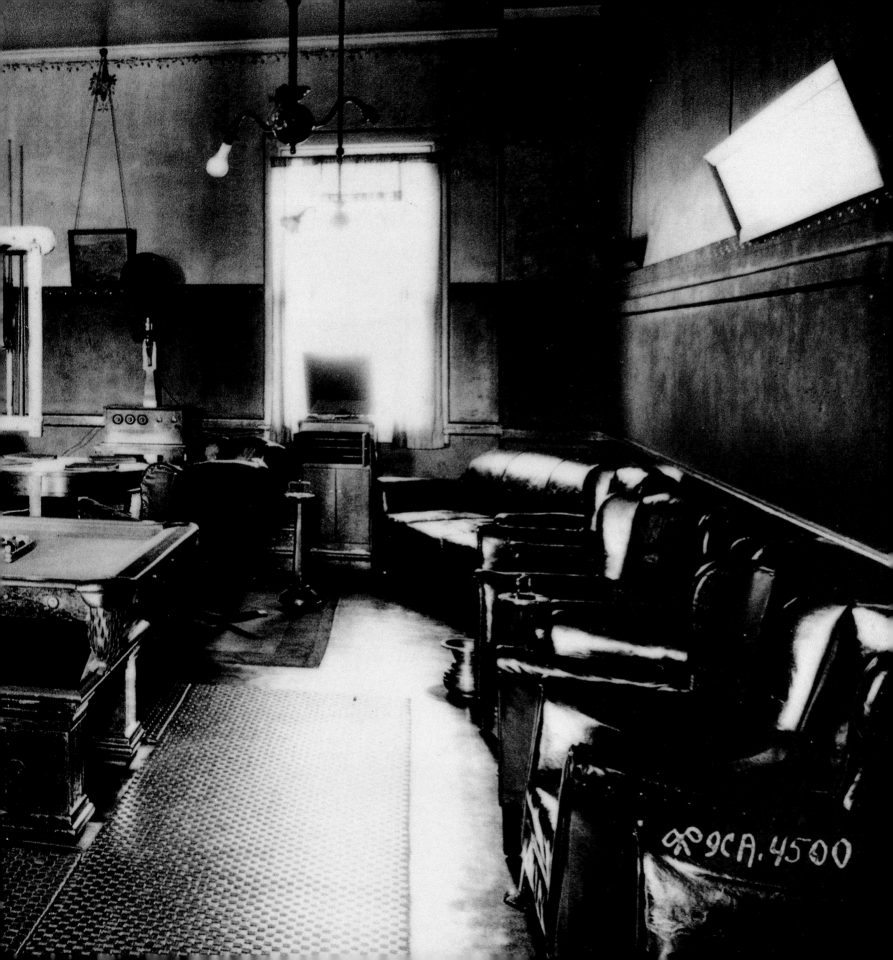

and auditoria, meeting rooms, medical facilities, and space to think about how to achieve an ecologically respectful world community. **E**ffective thinking about a future that may be better than the present necessitates rigorous analysis of the past, and the presence of fellow thinkers who can apply experience to an energetic determination that the future will, indeed, be better. One of the joys of the Presidio process is that there are such people already engaged in that endeavor. **T**he Presidio is a particular place, a place without equal for such an undertaking. In its setting of bay, ocean, sand dunes, forests, and streams, the Presidio is a context within which we can learn how to live more respectfully with each other, and with the other occupants of this magnificent creation—the Earth.

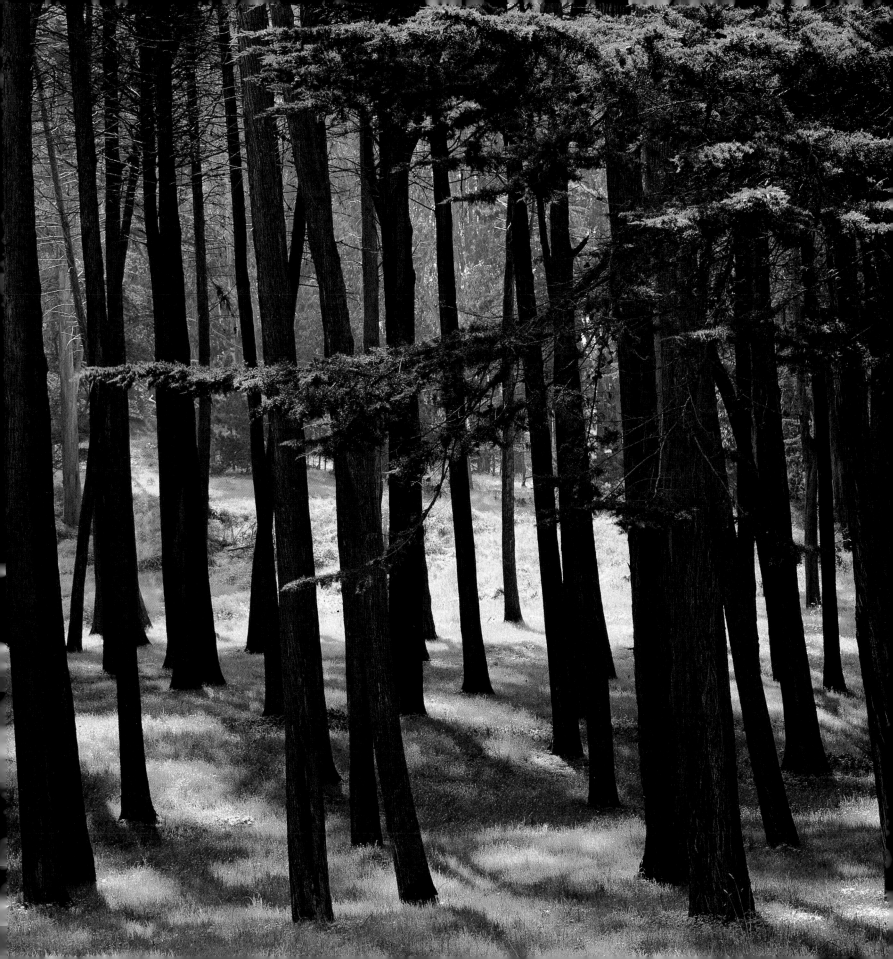

© AMY HOLM

ROBERT GLENN KETCHUM was born and has lived in Los Angeles since 1947, receiving his B.A. *cum laude* from UCLA and his M.F.A. from California Institute of the Arts, where he taught as part of the faculty during the 1970s. Since 1980, he has served as Curator of Photography for the National Park Foundation in Washington, D.C., and prior to that was Executive Director of the Los Angeles Center for Photographic Studies. He is currently on the Board of Councillors for the American Land Conservancy. His work is represented in major American photography collections and he has had over two hundred and fifty one-man and group shows.

Author of seven books, Mr. Ketchum was one of the first photographers to wed his work to his personal activism. Through titles such as *Overlooked in America: The Success and Failure of Federal Land Management* (1991, Aperture); *The Tongass: Alaska's Vanishing Rain Forest* (1987, Aperture); *The Hudson River and the Highlands* (1985, Aperture); and *American Photographers and the National Parks* (1980, Viking), Ketchum has used his subjects as metaphors for larger national and international environmental issues. In so doing, he has addressed the complicated politics of deforestation, federal management, and the preservation of wilderness.

In recognition of his remarkable success, he is one of only four photographers in the world to be given the United Nations Outstanding Environmental Achievement Award. He also received the Ansel Adams Award for Conservation Photography, and in June 1992, he was invited by the U.S. Embassy in Brazil to represent American art at the UNCED/"Earth Summit" Conference with a one-man exhibition at the National Museum of Fine Arts in Rio de Janeiro.

I played three different roles in this project and each had a different requirement and purpose. As curator of the vintage photography, I sought pictures that described particular periods in the Presidio's more than two hundred years of existence. Sorting through thousands of images revealed a remarkable history of change, which I hope is expressed in the inevitable edit.

As photographic project director, I wanted to work with photographers who I thought would complement the diversity of the subject and recognize its particular wealth of architecture and artifacts. Also, because I have always appreciated the interplay between black-and-white and color photography, I felt that the project would be most appropriately served by bringing both points of view into the process.

Lastly, as a participating photographer, I received the gift of a new viewpoint with this project. The Presidio has been one of my most urban subjects and I have come to appreciate it as a unique web of human and natural resources. The challenge that faces the National Park Service is to successfully integrate these lands into the Golden Gate National Recreation Area, one of the greatest urban, suburban, and parkland complexes in the world. What I hope we have accomplished with the project is the commemoration of the Presidio's past, while inspiring the public with the potential of its future.

© JUDITH McMILLAN

© ANIKA S. SHUKUYA

LINDA BUTLER brought to the Presidio a talent for capturing black-and-white interior architecture and still-life compositions. Her fascination with interiors is evident in her two photographic books, *Rural Japan: Radiance of the Ordinary* (1992, Smithsonian Institution Press) and *Inner Light: The Shaker Legacy* (1985, Knopf, text by June Sprigg).

Ms. Butler has received grants from the Ohio Arts Council, the Kentucky Arts Council, and the Kentucky Foundation for Women. She is a graduate of Antioch College and the University of Michigan. Her work is included in numerous museum collections and has been exhibited widely in the U.S. and Japan. Currently, she is working on photographs of interiors, still-life objects, and architecture in northern Italy.

When I discovered the drawers and closets in the basement of the Presidio Museum, it was like finding fresh water in a desert. I sorted though canteens, Civil War rifles, Prussian hats, WACs' wool stockings, and cracked leather army boots. Occasionally I came across an artifact, like the slightly squashed bugle (page vi), that seemed to demand to be photographed.

The curator dated the bugle as Spanish-American War vintage. When we conferred about what other items in the collection might accompany it, I suggested gloves. In a drawer, we discovered beautifully stitched leather gauntlets from the same period, which seemed to be ideal companions to the bugle.

Three months later when I returned to continue my photography, I found the bugle on the metal shelf where I'd left it, but the gauntlets were gone. The collection had been divided between the army and the National Park Service, and the gauntlets were sent to begin a new life at another military museum.

MARY SWISHER brings her interest in architecture to the Presidio. *Architectural Terra Cotta of Gladding, McBean* (1989, Windgate Press, text by Gary Kurutz) features her studies of exteriors and interiors of century-old pottery. The recipient of several National Endowment for the Arts awards and a California Arts Council grant, she holds a B.A. in art and M.A. in photography. Ms. Swisher's work has been exhibited in museums and published in numerous books and catalogs in the U.S., England, and Japan. She is currently photographing architecture, landscape, and traditional life of Mani, a remote region in the Southern Peloponnese of Greece.

My first visit to the Presidio of San Francisco was more than thirty years ago. From the Midwest, I was awed by the vistas of ocean and dark eucalyptus forest. Documenting the architecture in this environment—the world's most spectacularly beautiful location for a military base—provided rewarding discoveries.

Worn paving bricks in the cavalry stables and decaying dog kennels lay eerily silent. Long, windowed corridors in the Letterman Hospital sparkled in the afternoon sun, a reminder of those who lived and suffered through the ravages of World War II. Children now play outside Crissy Field Officers' Quarters, and high school students dance on nearby Battery Godfrey, the Pacific Ocean at their feet and Golden Gate Bridge towering to the northeast.

The army was diligent in maintaining their heritage, and by extension, our heritage. These photographs will serve as benchmarks. The National Park Service has taken up the challenge to use and preserve this rare urban acreage and historical architecture for generations to come.

© LISA GOMES

© JED MANWARING

LYLE GOMES is a native San Franciscan who received a master's degree in photography from San Francisco State University. Since 1984, he has served as coordinator of the photography department at the College of San Mateo. His photographs have been exhibited nationally and internationally and are in numerous permanent collections. Best known for his masterfully printed images, works that achieve a delicacy seldom seen in photography, his ability to capture the subtleties of flat, monochromatic, sun-softening fog in striking panoramic-format photographs is evident in the images included in this book. Lyle Gomes' photographs are from a project begun in 1989, entitled "The Presidio: A City Woodland."

Unlike the natural forests we carve out, the Presidio woodland was created, deliberately woven into our twentieth-century existence by its primary designer, Major William Albert Jones, in 1883. Fog obscures our vision and creates the illusion of an infinite forest in a relative economy of trees and space; by showing less, fog alludes to more.

BRENDA THARP, a California-based photographer and writer, exchanged the world of computers for the world of photography a decade ago. Early on, she studied under National Geographic photographers, concentrating on nature, travel, and photojournalism. Her work has been published in numerous magazines as well as in four books: *Marin Headlands* (1993, Golden Gate National Park Association); *Water Hole: Life in a Rescued Tropical Forest* (1992, New England Aquarium); *Mother Earth: Through the Eyes of Women Photographers and Writers* (1992, Sierra Club); and *Muir Woods: Redwood Refuge* (1991, Golden Gate National Park Association).

My passion is to share the beauty that I see in nature, in people, and in the world. If I can inspire someone to preserve and protect that beauty, I will truly have accomplished something.

KIT HINRICHS, art director, is a California native in the internationally renowned design group, Pentagram. With work in the permanent collections of the Museum of Modern Art and the Library of Congress, and the co-authorship of three books (*Vegetables* and *Stars & Stripes,* Chronicle Books; *TypeWise,* North Light Books) to his credit, Mr. Hinrichs contributes to the group's well-earned reputation. In the course of his career, he has received hundreds of national design awards for his work on a broad spectrum of projects, among them, museum exhibitions, annual reports, packaging, editorial graphics, and marketing promotions. Mr. Hinrichs chaired the American Instutute of Graphic Arts California Design Exhibition in 1982; was elected to membership in the Alliance Graphique Internationale in 1989; and is on the Board of Trustees of the Golden Gate National Park Association.

DELPHINE HIRASUNA, writer and principal of Hirasuna Editorial, San Francisco, adds her work on the text of this book to a long list of publications, most notably *Flavors of Japan* (co-authored with her sister Diane); the Smithsonian's *A Historical Review of Annual Reports;* and *Vegetables, Stars & Stripes,* and *TypeWise* (co-authored with Kit Hinrichs). Born and raised in California, Ms. Hirasuna also writes a weekly feature column for two of the largest Japanese-American daily newspapers, *Rafu Shimpo* and *Hokubei Mainichi.* She serves corporate clients nationwide and has provided award-winning text for annual reports, brochures, video scripts, and corporate profile books.

ROGER KENNEDY has invested much of his adult life in the study and preservation of America's past. Prior to his appointment as director of the National Park Service in 1993, he was director of the Smithsonian Institution's National Museum of American History (1979 to 1992) and a vice president of the Ford Foundation (1970 to 1979). General editor of the *Smithsonian Guide to Historic America,* Mr. Kennedy is also the author of seven books, including *Rediscovering America,* basis of the television program "Roger Kennedy's Rediscovering America," and the recently published *Mission,* an examination of the Spanish mission system in North America. Upon taking charge of the NPS, Mr. Kennedy said that "we humans are challenged every day to make this world a better place. It is my belief that we must learn all that we can about the Earth in order to live upon it wisely," and his work embodies this belief.

DUGALD STERMER, map artist, is a multi-talented freelance designer and illustrator who has received gold and silver medals from the New York Art Directors Club; designed the official medals for the 1984 Olympic Games; and created editorial illustrations for *Time, Esquire, The New York Times, The Washington Post, Monthly Detroit, SF Focus,* and *California,* among others. A one-man retrospective exhibit of his work was held in 1986 at the California Academy of Sciences. Mr. Stermer, a native Californian, has written extensively for *Communications Arts,* has had two books published—*The Art of Revolution* and *Vanishing Creatures*—and has two new books scheduled for release in 1995: *Vanishing Flora* and *Birds and Bees.*

PHOTOGRAPHIC INDEX

COVER

*Golden Gate Bridge above
Fort Point*
Robert Glenn Ketchum

CONTENTS

Trail in Presidio Forest
Lyle Gomes

INTRODUCTION

page vi

*Bugle and Leather
Gauntlets, 1890s Vintage*
Linda Butler

page 2, top left

*Ohlone Indian
sketch by Michael Harney
from* Ohlone Way,
*by Malcolm Margolin
Heydey Books*

pages 2-3

*Presidio Boulevard Gate,
ca. 1906
courtesy Presidio Museum,
Golden Gate National
Recreation Area*

page 3, top right

*Juan Bautista de Anza III
from* The Explorers,
Copley Press

page 5

*Quartermaster's Records,
Unit Ledger 1873-74*
Linda Butler

page 6, top left

*Presidio Crest
courtesy Sixth U.S. Army*

pages 6-7

*Field Artillery at
Main Post, ca. 1910
courtesy Presidio Museum,
Golden Gate National
Recreation Area*

page 7, top right

Mexican Flag

page 8

*Canteen and Springfield
Rifle, Civil War Vintage*
Linda Butler

page 10

*John C. Fremont
courtesy Presidio Museum,
Golden Gate National
Recreation Area*

pages 10-11

*The Alameda
courtesy Presidio Museum,
Golden Gate National
Recreation Area*

page 11, top right

*Quartermaster Uniform,
ca. 1865
courtesy Presidio Museum,
Golden Gate National
Recreation Area*

pages 12-13

*Soldiers Departing through
Lombard Gates, 1898
courtesy National
Park Service*

page 15

*Cavalry Boots, World
War II Vintage*
Linda Butler

page 16, top left

*Military Hat Device
courtesy Colonel Milton
B. Halsey, Jr.
photograph courtesy Bob
Esparza*

pages 16-17

*Martin Bombers at
Crissy Field
courtesy Presidio Museum,
Golden Gate National
Recreation Area*

page 17, top right

*Pre-forest Military
Grounds
courtesy Presidio Museum,
Golden Gate National
Recreation Area*

page 18

*WAC Uniform,
WW II Vintage*
Linda Butler

NORTH GATE

page 25

Golden Gate Headlands
Linda Butler

pages 26-27

*Golden Gate Bridge
above Fort Point*
Robert Glenn Ketchum

page 27

*Sally Port Door,
Fort Point*
Linda Butler

page 28

*Bench along Golden Gate
Promenade*
Brenda Tharp

pages 28-29

Pilot's House
Mary Swisher

pages 30-31

*Golden Gate Bridge and
Doyle Drive*
Robert Glenn Ketchum

page 32

*Mission Revival-style
Building, Fort Scott*
Robert Glenn Ketchum

page 33

Cavalry Barracks
Mary Swisher

pages 34-35

*Golden Gate Bridge from
Main Post*
Lyle Gomes

pages 36 and 37

*Dutch Colonial Revival-
style Residence,
Coast Guard Station*
Mary Swisher

pages 38-39

*Crissy Field and the City
of San Francisco*
Robert Glenn Ketchum

page 40

*Mediterranean Revival-
style Guard House*
Mary Swisher

pages 40-41

*San Francisco National
Military Cemetery*
Robert Glenn Ketchum

pages 42-43

*Residence,
Fort Winfield Scott*
Mary Swisher

page 44

*Fort Point under
Golden Gate Bridge*
Linda Butler

page 45

*Cultivated and Native
Plants, Fort Winfield Scott*
Robert Glenn Ketchum

*page 46, top left, and
page 47, top right*

*Mission Revival-style
Buildings,
Fort Winfield Scott*
Robert Glenn Ketchum

pages 46-47

*San Francisco National
Military Cemetery*
Linda Butler

page 48

*View from Coast Guard
Residence Porch*
Linda Butler

pages 48-49

*Mediterranean Revival-
style Administration
Building, Crissy Field*
Robert Glenn Ketchum

page 50

*Granite Staircase,
Fort Point*
Linda Butler

page 51

Golden Gate Promenade
Brenda Tharp

pages 52-53

Pet Cemetery
Robert Glenn Ketchum

pages 54-55

Casemates, Fort Point
Linda Butler

page 55

*Mission Revival-style
Building, Fort
Winfield Scott*
Robert Glenn Ketchum

SOUTH GATE

page 57

*Belladonna Lilies,
Tennessee Hollow*
Mary Swisher

pages 58-59

Tennessee Hollow
Mary Swisher

page 59

*Georgian Revival-style
Residences,
Tennessee Hollow*
Robert Glenn Ketchum